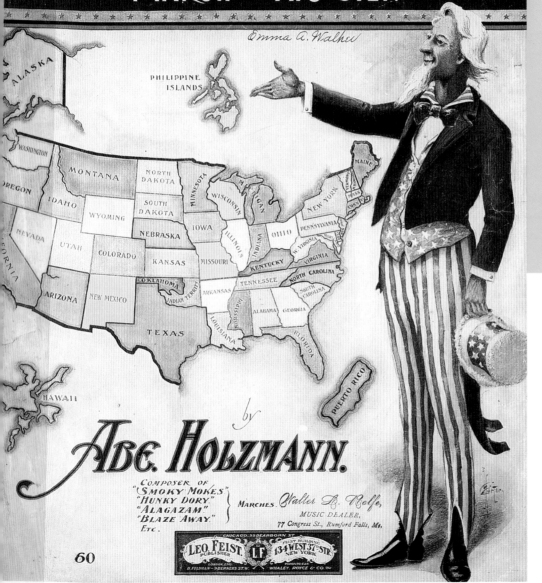

UNCLE SAMMY
MARCH ~ TWO-STEP.

Emma A. Walker

by

ABE. HOLZMANN.

COMPOSER OF
"SMOKY MOKES"
"HUNKY DORY."
"ALAGAZAM"
"BLAZE AWAY"
ETC.

MARCHES. } *Walter L. Wolfe,*
MUSIC DEALER,
77 Congress St., Rumford Falls, Me.

60

LEO. FEIST
PUBLISHER **LF**
CHICAGO, 59 DEARBORN ST
FEIST BUILDING
134 WEST 37TH STR
NEW YORK
LONDON, ENG.
B. FELDMAN – 9 BERNERS ST. W.
TORONTO, CAN.
WHALEY, ROYCE & CO.

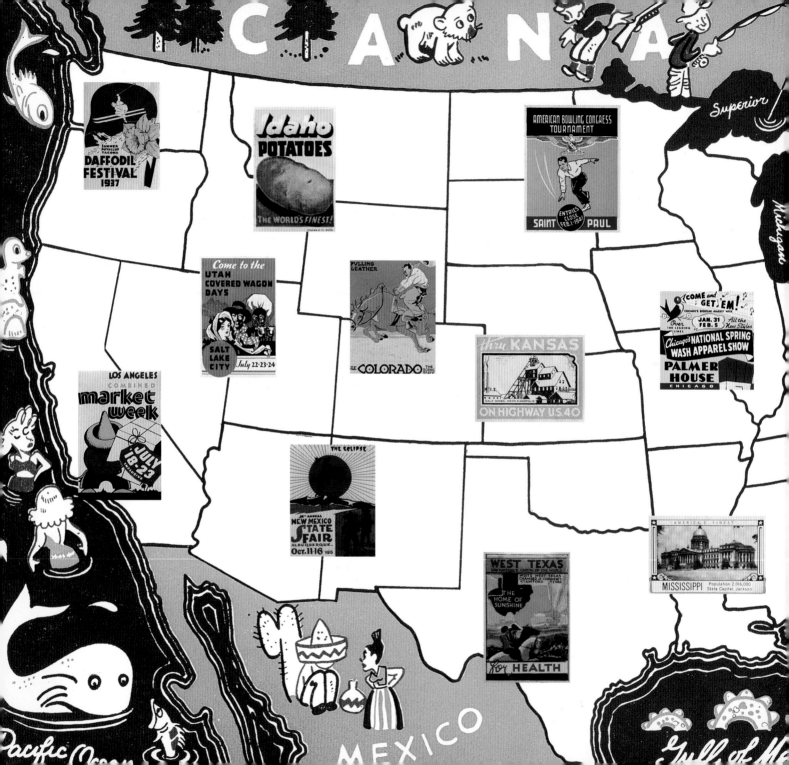

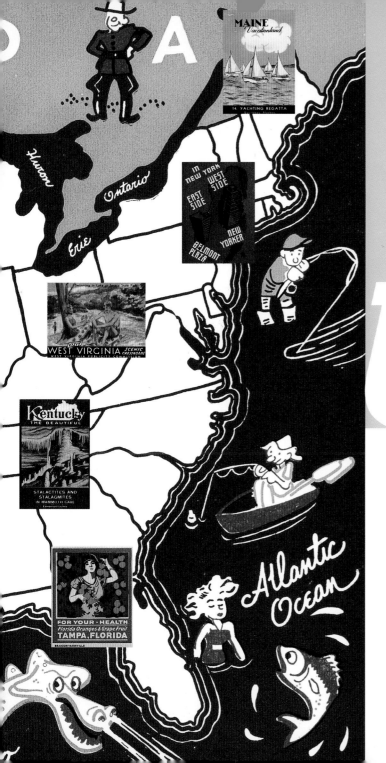

SEE THE USA

THE ART OF THE AMERICAN TRAVEL BROCHURE

JOHN MARGOLIES ★ ERIC BAKER

CHRONICLE BOOKS
SAN FRANCISCO

Some of the illustrations in this book are published with the permission
of private collectors, institutions, and corporations who are identified in
the Sources List on page 128.

Library of Congress Cataloging-in-Publication Data available.

ISBN 0-8118-2272-9

Printed in Hong Kong.

Designed by Eric Baker Design Associates, Inc., NYC
Photography by Becket Logan

Distributed in Canada by Raincoast Books
8680 Cambie Street
Vancouver, British Columbia V6P 6M9

10 9 8 7 6 5 4 3 2 1

Chronicle Books
85 Second Street
San Francisco, California 94105

www.chroniclebooks.com

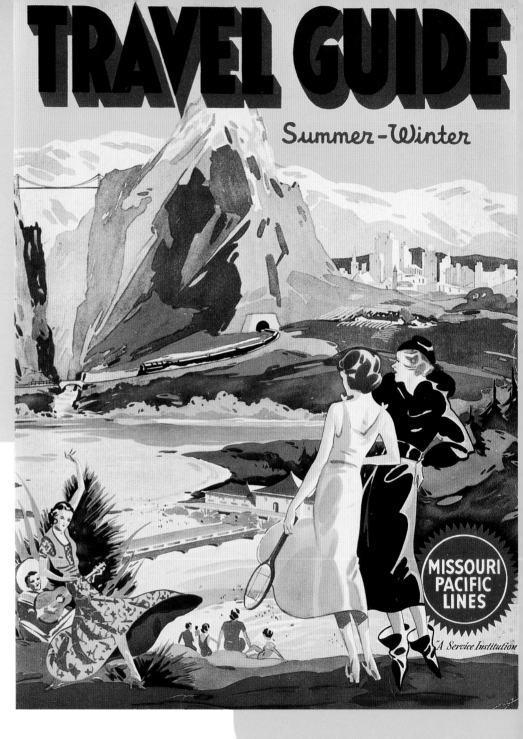

Contents

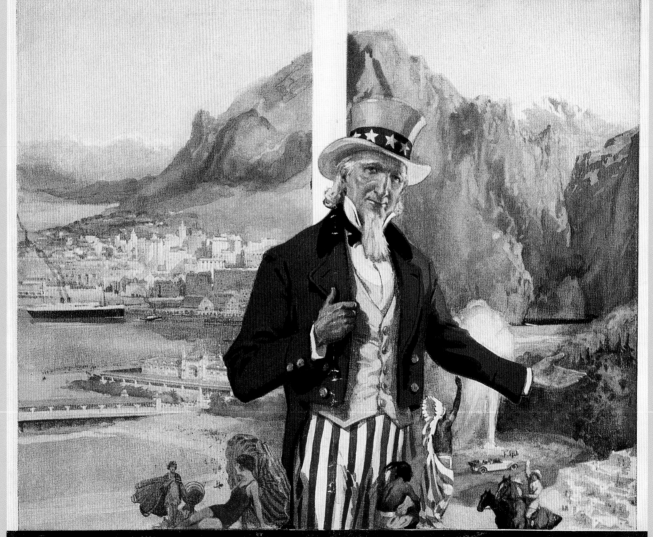

Missouri Pacific
brochure, 1928

Since the United States was founded, Americans have earned and relished a reputation for being on the move. We travel, take vacations, and relocate. As the country has grown and developed in the nineteenth and twentieth centuries, cities, states, and regions have enthusiastically promoted themselves to attract tourists as well as to lure business and industry and the money and jobs they provide. Multitudes of handsome travel brochures and booklets have played a key role in attracting the throngs.

These brochures have been created and distributed by many different types of organizations; by state and county tourism agencies, small town and big city chambers of commerce, and co-operative regional agencies, as well as by the companies providing the transportation to get to these celebrated locations. Railroads, bus companies, airlines, and steamship lines have not only glamorized their own means of transportation but embellished their brochures with technicolor visions so tempting that tourists could scarcely wait to hop aboard and explore the wonders of their own country. Tour operators are another major producer of travel brochures and booklets, including Thomas Cook, Raymond-Whitcomb, American Express, and smaller outfits that organize and promote complex travel packages. Their two and three week journeys are promoted with lavish descriptions, views, and prices for all of the fun being offered.

The travel brochure experienced its golden age in the period prior to World War II—examples from that time stand out as the most artistically interesting and vibrant. These are the years in which travel began to burgeon in the United States. While brochures have been produced in abundance ever since, the post-war examples tend to be less extravagant and engaging in their presentation than their prewar predecessors.

To best appreciate the art of travel brochures, one needs to understand these within the context of travel advertising. This advertising has been targeted toward two distinct audiences, "travelers" and "tourists." Travelers are those people who tour the country in the course of conducting business or who are looking for a place to locate or relocate; tourists are people on vacations or journeys of exploration. Before travel brochures as we know them today, broadsides, newspaper notices, and magazine advertising were used to reach these audiences.

Of these two types of consumers, tourists are unquestionably the major target audience for promotional travel literature. Encouraging tourism has always been the primary function of travel brochures. However, the vacation didn't always exist as it does today. In early-nineteenth-century America, it was a pleasurable activity mostly reserved for the well-to-do. Only after the Civil War did it become commonplace for most Americans. The Industrial Revolution, the rise of labor unions, improvements in transportation, and the resulting creation of a new middle class all helped to create the institution of the modern vacation. Ordinary people

American Travel Brochures:

Selling the Dream

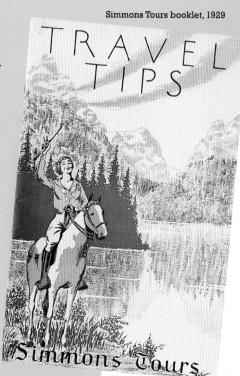

Simmons Tours booklet, 1929

TRAVEL TIPS

Simmons Tours

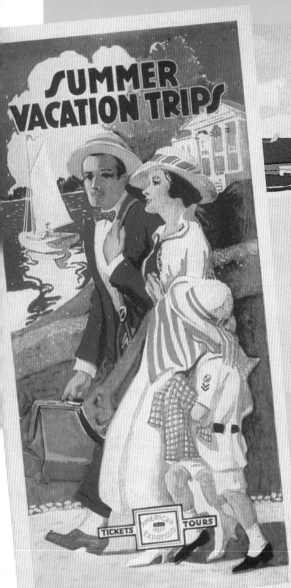

SUMMER VACATION TRIPS

TICKETS TOURS

TRAVEL DEPARTMENT
AMERICAN EXPRESS COMPANY

From left: American Express
brochure, 1917; Fish story illustration,
Tropical Trips brochure, 1933;
Island brochure, c. 1930

·LONG ISLAND·

"America's Sunrise Land"

became happy wanderers as they were given the means to experience the joy, awe, and splendor of discretionary travel.

Several types of tourist-directed publications have arisen to entice them: travel brochures, booklets, viewbooks, and guidebooks. Brochures are a visual mix of photographs, illustrations, and maps with a liberal dose of information-laden advertising copy, and booklets are usually larger, more involved versions of brochures. Travel guides are nearly as common as brochures; however unlike brochures they present ostensibly objective advice as well as information on accommodations and amenities. Viewbooks are albums of beautiful illustrations with very little written information, thus they can be considered a souvenir as well as an advertising come-on. Although not as lavishly produced as a viewbook, the souvenir postcard folder is its close relative. These ubiquitous little accordionlike viewbooks display a two-sided array of postcard-size images experienced as a continuous unfolding of seams. The postcard folder, in turn, evolved from the accordion-brochure of the late nineteenth century, a seemingly endless series of images printed on one side only that sometimes, when fully spread out, was six, seven, or eight feet long.

Travel brochures and booklets have been produced in a great variety of formats, many variations on a few formulas. The two most common types are the foldover and the booklet bound with staples or string ties.

In its most simple and economical form, the foldover is a single sheet of paper, usually 9 by 12 inches and printed on both sides, which is then folded over twice to form a single panel of 4 by 9 inches ready for placement in a road map–like rack. A more complex and expensive foldover uses a longer sheet of paper, so that instead of three folds, the brochure folds out four, five, six times or more. Even more complex foldovers—adding a horizontal fold or folds as well as a number of vertical divisions—create road map–like problems in putting them back together. And the simplest foldover, and one used quite often to mass produce inexpensive contemporary leaflets, has no fold at all; it's just one 4-by-9-inch card, ready to place in racks.

The travel brochure booklet is just that—pieces of paper in various dimensions printed and then bound at the center fold. While this format doesn't always fit in conventional brochure racks, its traditional book format permits

Niagra Falls foldout viewbook, 1895

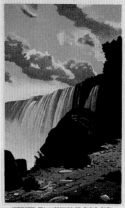
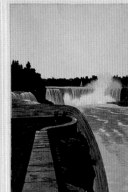

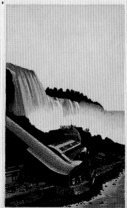
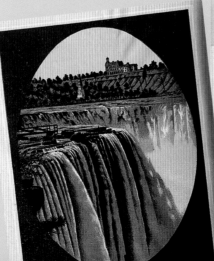

a simpler, logical presentation of more complex and lengthier content. The booklet format has sometimes been further complicated by printing the cover image on the back page of the publication. This "front page-back page" is folded to fit into a rack so that it opens on the left side at the back rather than from the traditional right side. The reason for doing this, it seems, is to display a colorful image to attract rack browsers who then pick out the booklet and are compelled to turn the booklet over to begin at page one.

A delightful and expensive variation on both of these two common types of travel booklets and brochures is the "die cut," where the cover and all pages are stamped out at the printer into the shape of the place being promoted—such as the state capitol in Denver, Colorado, or an outline of the state of Georgia. The die cut works reasonably well as a bound booklet (hand-tied or saddle stitched), although little bumps or corners are easily bent by the user. But die-cut foldovers, right, are a nightmare of complexity, much too easy to tear, damage, or destroy when trying to look at them and almost impossible to reassemble.

The travel brochure is an overlooked form of commercial art. Even though some of their full-color cover illustrations are, in and of themselves, among the very finest examples of American commercial art, little attention has been given to them. Eric Friedheim, an award-winning travel business writer and author of the book *Travel Agents,*

commented in an interview that he's never devoted much thought to the brochures themselves. In the literature of travel and graphic design, only two books have been devoted exclusively to the travel brochure—one about Hawaii by DeSoto Brown and the other about Florida by Jeff LaHurd. Many other books have used the travel brochure as a means to an end, expropriating the images to illustrate other points.

These brochures reflect the graphic art styles of the eras in which they are created as well as the unlimited imaginations of the illustrators—striking poster art, impressionistic and expressionistic landscapes and cityscapes, and highly stylized art deco confections adorn the covers of these promotional tours de force. The illustrations are invariably conceived to glorify the places they represent. Their content is varied and nearly always idealized. Romantic views rendered in bright and sometimes fanciful colors depict perfect people in paradise at play or at work. Mundane places are transformed into Oz, and fantastic places approach Nirvana itself. Most of this commercial art is created by unknown artists, although sometimes a well-known artist or illustrator is employed, such as John Held Jr. who illustrated many brochures for the New York, New Haven, and Hartford Railroad.

The text for nearly every brochure is pure, unadulterated advertising copy—the product of generations of advertising copywriters and eager chamber of commerce promoters. Much of the promotional text is amusing and artful,

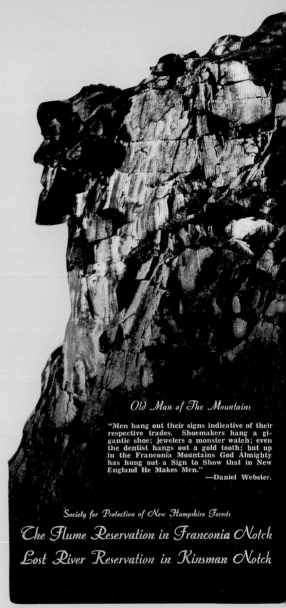

Old Man of The Mountains

"Men hang out their signs indicative of their respective trades. Shoemakers hang a gigantic shoe; jewelers a monster watch; even the dentist hangs out a gold tooth; but up in the Franconia Mountains God Almighty has hung out a Sign to Show that in New England He Makes Men."
—Daniel Webster.

Society for Protection of New Hampshire Forests
The Flume Reservation in Franconia Notch
Lost River Reservation in Kinsman Notch

New Hampshire die-cut brochure, 1941

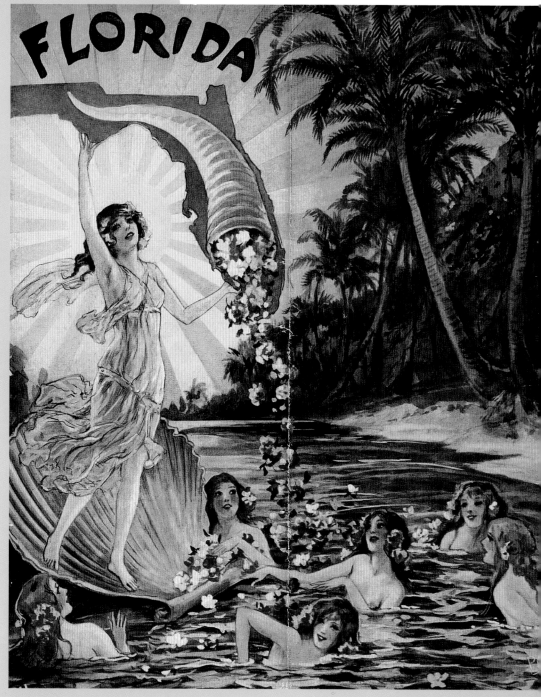

FLORIDA

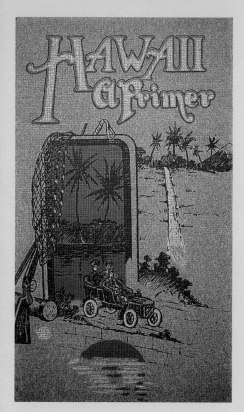

Above, Hawaii booklet, 1905
Right, *Florida Facts* brochure, 1928

sometimes deliberately so, but more often because it is deep-purple prose chock-full of effusive adjectives, clichés, hyperbole, and exaggeration. When a brochure needs to extol, say, North Dakota in winter, the publicity person really has to stretch to say something alluring. But when a copywriter has paradise on earth to describe (take Florida or Hawaii, for example), then flowery prose knows no bounds. A 1928 brochure, *Florida Facts,* exudes: "Florida is the land of romance, legend, song and story. . . . It is bathed in the

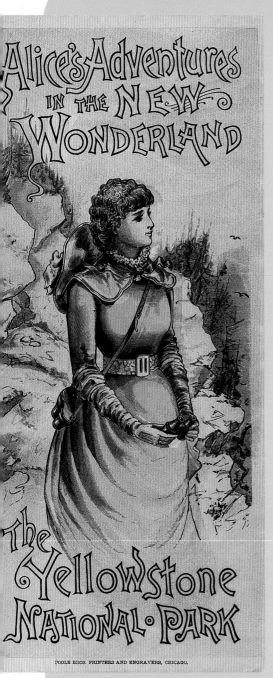

Alice's Adventures in the New Wonderland

The Yellowstone National Park

POOLE BROS. PRINTERS AND ENGRAVERS, CHICAGO.

Yellowstone Park brochure, 1885

passionate caresses of the southern sun, laved by the limpid waves of the embracing seas, wooed by the glorious Gulf Stream. . . . An emerald kingdom by southern seas, fanned by zephyrs laden with ozone from stately pines, watered by Lethe's copious libation, decked with palm and pine, flower and fern, clothed in perpetual verdure and lapt in the gorgeous folds of the semi-tropical zone." And this 1905 description of Hawaii is pure paradise in and of itself: "These fortunate isles offer to the visitor the perfection of climate, bright sunshine, blue skies, a summer sea, splendid mountain vistas, high peaks, deep valleys, brilliant-hued verdure, shining moonlight, excellent drives, unsurpassed accommodations. It is as well a land of attraction by negatives, for there are no fogs, no hurricanes, no typhoons, no tidal waves, no sandstorms, no frost, no sunstroke, no malaria, no poisons, no reptiles, no wild beasts."

While Florida and Hawaii have an ideal year-round climate, some locations become attractive for only a season. The copywriter in one 1912 brochure makes a persuasive case that Duluth, Minnesota, is the place to be in the summer: "To a great proportion of the population of these United States, summer is a season of tribulation; often of positive suffering. While the mercury mounts steadily in the tube, and no breath of cooling wind comes to stir the sluggish air, work becomes more and more unprofitable, and pleasurable recreation more impossible.

"Sunset brings no relief: the stagnant air swirls sluggishly through the sun-baked streets, the sidewalks send back a glow as from the wall of a furnace: the unhappy dwellers in the inland cities toss restlessly on stifling, sleepless couches, and rise all unrefreshed to front another day of unprofitable toil.

"To all such the Summer-City of the Continent says 'Come!' Delightful Duluth beckons the heat-weary with promise of sure relief."

Escanaba, Michigan, has been billed as another soothing place to be in the summer: "In the Upper Peninsula one may enjoy cool, restful nights, days of glorious sunshine, clear waters of bays, inland lakes and streams where exhilarating air and the scent of the balsam and pine speedily restore health and vigor. Jaded appetites, unstrung nerves, insomnia, hay fever, and a score of other ills cannot endure the climate of the Upper Peninsula. Insect pests and foul water are extremely rare. Poisonous snakes are unknown."

Not only cities, states, and regions but also a wide variety of natural attractions have been the subjects for travel promotion. With the founding of Yellowstone National Park in 1872, the federal government began to issue informational booklets. But these straightforward guides could not begin to compete with the brochures put out at the time by the Great Northern Railway. The Great Northern Railway brochures described Yellowstone as "Wonderland" as early as the 1880s. The railway issued spectacular annual Wonderland travel booklets with stunning cover illustrations,

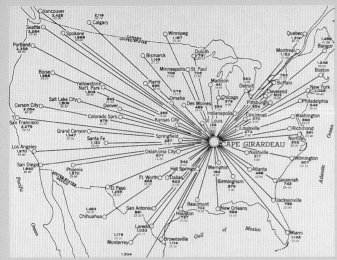

Cape Girardeau mileage chart, c. 1950

each one more beautiful than the last, to attract tourists into the ether of the wild blue yonder. Other railroads, including the Union Pacific, also issued Yellowstone literature, and many other carriers have touted the natural beauties of their territories.

Caves are another type of natural attraction that has relied on promotional brochures, perhaps even more than some other types of attractions since their splendors are hidden underground. Although a few caves have been operated by government agencies, most have been privately owned and operated. Plentiful tourist brochures reinforced by billboards lead visitors to the great undergrounds. A brochure issued by Duhamel's Sitting Bull Crystal Caverns in the Black Hills of South Dakota, for example, extols the time-saving virtues of their attraction: "We do not ask you to use your imagination as this awe

inspiring sight will thrill you through and through. We warrant and guarantee that you will see more in the Sitting Bull Crystal Caverns in one and one-half hours than you will see in any other cavern on the North American continent in five hours."

Large and sophisticated venues have had no problems finding highlights to feature in their advertising. But more humble locales often resort to exaggeration to make up for the lack of the beautiful or the sublime. It is important to bear in mind that these cities and towns have sought to attract permanent residents as well as tourists. While it is easy to wax poetic about an ocean, a lake, or a mountain range, less-endowed locations have had to stretch to create a sense of distinction. Take a city like Altoona, Pennsylvania, for example. While it is located in the Allegheny Mountains, it has had much heavy industry. Altoona's travel literature from the 1930s ballyhoos the famous horseshoe curve along the east-west rail route and also makes the claim that Altoona is the "recreation center of West Central Pennsylvania."

Other small towns boast of the commerce in their downtown business districts. Keene, New Hampshire, "the largest city within a radius of forty miles," brags of its retail sophistication

in a 1930 brochure: "Keene . . . has approximately two-hundred retail stores. . . . Being such a short distance from Boston and New York, you may be served with all that fashion decrees." And the tiny town of Delphos, Ohio, in a primitive brochure issued in the 1930s speaks of its "modern retail outlets" and merchants offering "such services as friendly, helpful sales clerks; adequate supply; numerous selections; various 'free services'; convenient parking facilities" and more.

But some small towns just have not had enough money to provide lavish travel brochures. In Ashland, Wisconsin, the secretary of the chamber of commerce wrote a hand-typed letter dated August 11, 1933; responding to a tourist's inquiry, he understated his town's virtues: "We regret we are too poor to be very well supplied with literature, however, we enclose a booklet which in a way is descriptive of Ashland and vicinity. We believe we have some very pretty drives in the surrounding country which should be interesting. The Fish Hatchery is on highway 13 on the way to Bayfield and open to visitors. . . . If you conclude to come this way, give us a call for more definite information."

Other remote places have tried to disguise this fact as best they can. One oft-repeated visual device has been to create a map showing the small town in relation to many of the actual nerve centers of the United States. The trick is to devise a map constructed with the town (say, for instance, Cape Girardeau, Missouri) as the center of the universe,

with places like Chicago, St. Louis, Miami, and New York orbiting around it. The implication is clear: The world revolves around Cape Girardeau!

Some places—like Glendale, California, in the 1940s—have been so intent upon attracting certain settlers that they have resorted to less-than-veiled efforts to assure people that they would be living in a place with the "right" type of neighbors: "Because Glendale is a city whose ever-increasing population is composed of men and women representing the highest type of American civilization, gathered from all sections of the United States, you will find, as your neighbors, substantial folk who offer you the sort of contacts you desire. The population of Glendale is truly American, with practically no foreign element, and no foreign quarters or tenements." While such copy may be offensive to many readers today, it was not infrequent a few decades ago.

Other places have chosen to glorify their commuter-citizens. In 1926, the New York City suburb of New Rochelle waxed poetic about its populace: "The worth of our suburban places in America is that in them the vital flow of the great cities renews itself each night.

"In pleasant homes standing four square to the weather, refreshed by the clean winds, watched over by the visible stars, sturdy little populations, competent, helpful, progressive, accept life's gifts and meet its calls, with confident but unboasting self-reliance, to lend the surplus of their vigor to the profound needs and problems of the nation. That is their immeasurable contribution." This New Rochelle brochure even goes on to show us a perfect suburban family (right) awaiting the nightly return of the breadwinner.

With the approach of the millennium and the new world of technological advancement, there are now electronic brochures that exist only in cyberspace. Many people bypass the travel agent's office and make their own arrangements on line. And those who still use travel agents are now often charged a fee for these services—the agencies having been undercut by the companies offering their own services directly or on-line. Today, tour operators are the largest producers of travel brochures, offering packaged experiences, often in mass mailings, to specialized audiences as well as to the general public.

The means of distributing the traditional printed brochure have changed as well. Instead of racks full of brochures in all the old familiar places, now there are slick thirty-second TV commercials produced by states, regions, and cities and accompanied by toll-free phone numbers, making it easy to dial up and receive "fulfillments," as they're called in the trade-magazines of dreams and far-away places.

There are still racks full of rather anonymous-looking travel brochures out there—as ephemeral as ever. They are short and to the point, but they lack soul and artistic vitality. They are found in the new venues of motel lobbies, interstate rest stops, and at entrances to chain restaurants near the interstate. Sometimes they are even found in their old haunts: hotel lobbies, transportation terminals, and travel offices. However, the fact remains that the travel brochure has lost much of its effectiveness as it has been eclipsed by the Internet.

The demise of the golden age of travel literature has in its turn created an active collector's market. The older examples of travel literature, which have withstood the test of time by escaping trash baskets and been packed away in attics and basements, have become increasingly valued as collectibles on the ephemeral and antique paper market. Although the intent of these brochures was to advertise and promote a destination, the survivors have achieved a far greater value, not only as magnificent examples of graphic art, but as windows into the not-too-distant past when the entire experience of travel was a romantic adventure rather than a standardized experience.

These artifacts of advertising art, once given away to all takers, are now sold for tens and hundreds of dollars, depending upon their age, condition, and the state of their art. State and local historical societies and several specialized libraries across the United States, including notably the DeGolyer Library at Southern Methodist University in Dallas, the Wolfsonian Museum at Florida International University in Miami Beach, the John W. Hartman Center at the Duke University Libraries in Durham, North Carolina, and the Geroge Smathers Library at the University of Florida in Gainesville, now purchase, catalog, and

maintain vast collections of travel ephemera and advertising. The travel brochures shown in this book are examples of advertising that have become important not only as time capsules but sometimes as the only surviving record of a place or an era or an experience once shared in common by an enormous audience of travelers and tourists as they explored the wonders and the vastness of the United States. The basis for their selection is to show the best and the most representative rather than to try to include at least one example from each and every state. Larger, wealthier, and geographically blessed locations have had larger advertising budgets and usually have issued more and more spectacular advertising than the smaller and more remote areas. On the following pages travel brochures from over a hundred years of the art are allowed to speak their seductive language for themselves and to us all.

New Rochelle: The City of the Huguenots brochure illustration, 1926

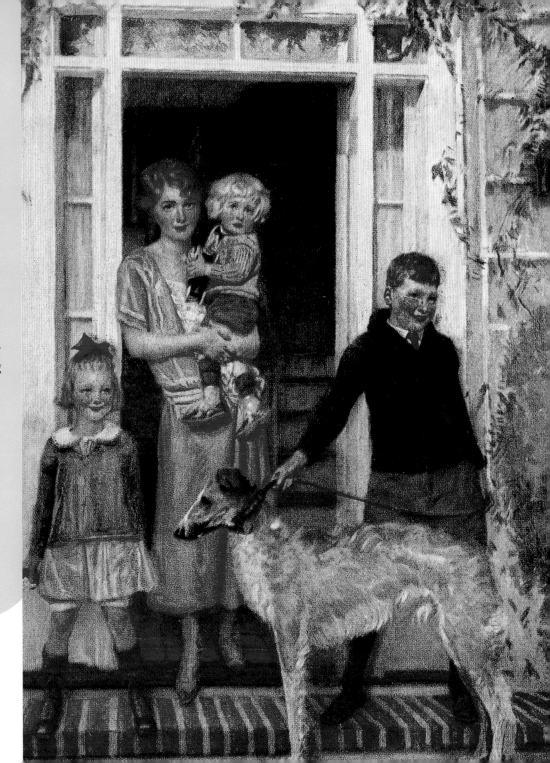

PARADE OF THE STATES

LAKE IN CRATER

OLD FAITHFUL

MT. WHITNEY

HIGHEST & LOWEST IN U.S.

DEATH VALLEY

NEW ENGLAND TOURS, 1918

"NATURE was in her most versatile mood when she planned New England. No like area in all the world holds so much of charm for the motor tourist. Thousands of miles of broad, white roads take him through country roads of rare scenic beauty, over the majestic Green and White Mountains, along the rocky shores of Maine, through the passive wonderment of the Naugatuck Valley and along the shores of Lake Champlain."

YOU DON'T KNOW BEANS TILL YOU'VE 'BEAN' TO BOSTON!

YOUR NEW ENGLAND VACATION

John Held Jr

WHERE TO GO··
WHAT IT WILL COST!

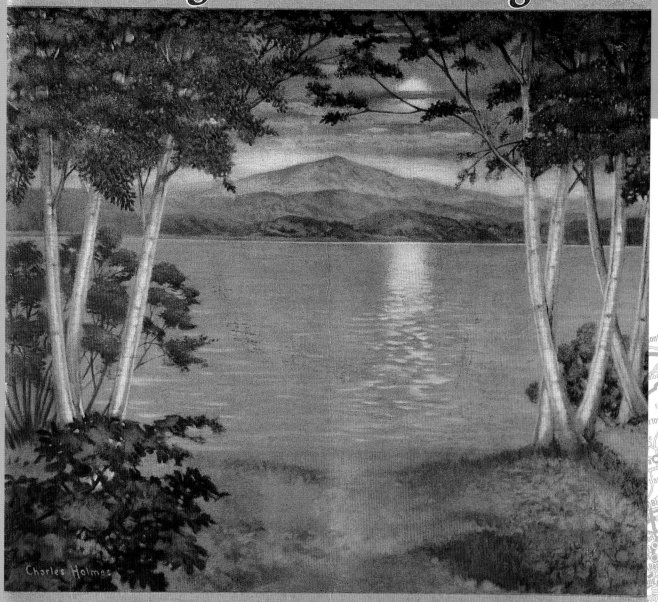

Summer in New England

Summer in New England

Charles Holmes

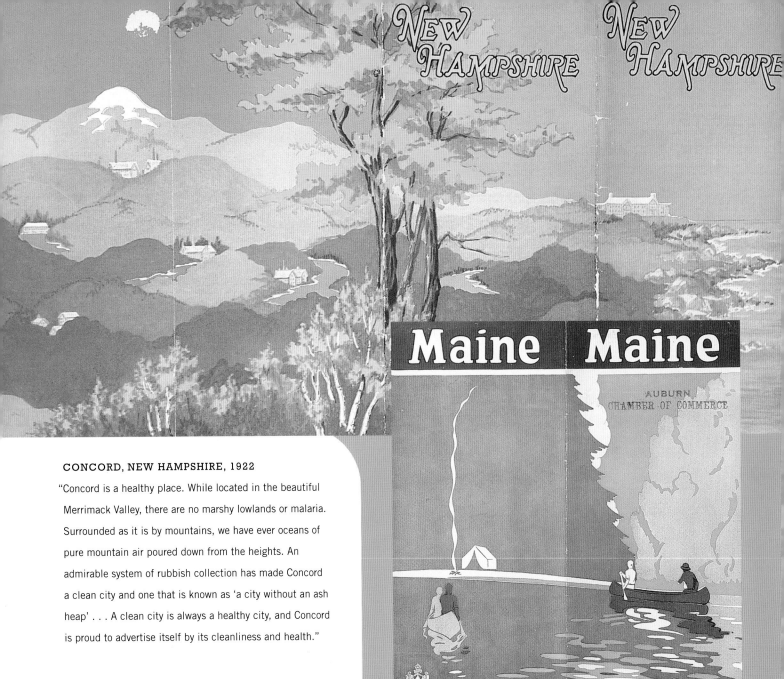

CONCORD, NEW HAMPSHIRE, 1922

"Concord is a healthy place. While located in the beautiful Merrimack Valley, there are no marshy lowlands or malaria. Surrounded as it is by mountains, we have ever oceans of pure mountain air poured down from the heights. An admirable system of rubbish collection has made Concord a clean city and one that is known as 'a city without an ash heap' . . . A clean city is always a healthy city, and Concord is proud to advertise itself by its cleanliness and health."

TROLLEYING A ROUND PORTLAND MAINE

RIVERTON

PORTLAND RAILROAD CO.

UNSPOILED VERMONT

VERMONT VERMONT

◄

UNSPOILED VERMONT, c.1950

"I love Vermont because of her hills and valleys, her scenery and invigorating climate, but most of all, because of her indomitable people. They are a race of pioneers who have almost beggared themselves to serve others."

Calvin Coolidge

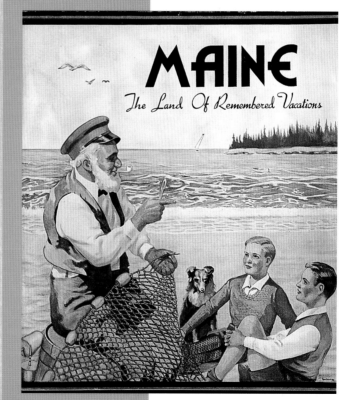

MAINE
The Land Of Remembered Vacations

THE REAL PHILADELPHIA, 1930 ▶

"There is nothing more interesting than the story of a city. The stories of nations are epics. Their characters and heroes are demigods. But the story of a city is the story of all of us. All cities are alike in many respects. What really counts is their points of difference. Let us examine Philadelphia's. It may add to your understanding of your own city."

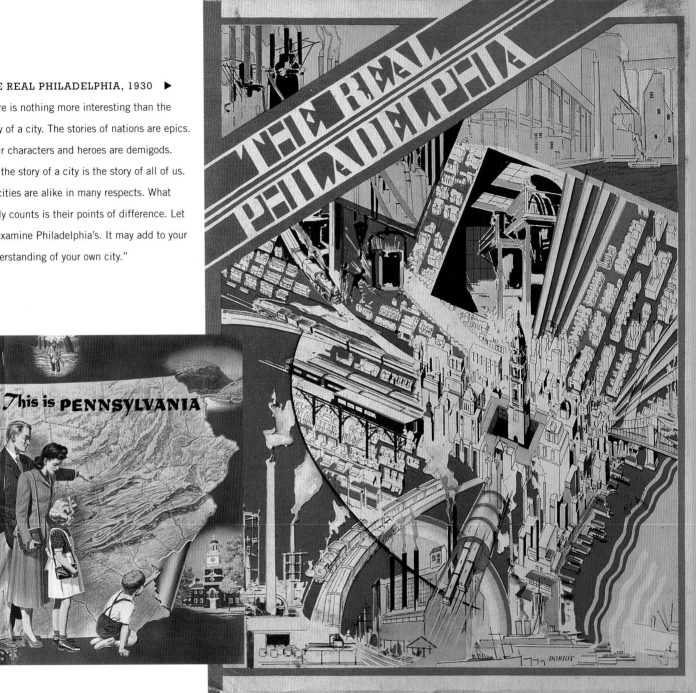

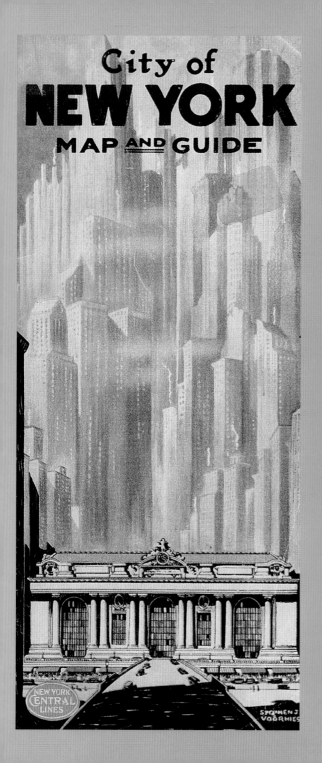

◀

CITY OF NEW YORK MAP AND GUIDE, 1930

"Do you want to feel dwarfed, insignificant, unimportant, overwhelmed and the next moment like an exultant god? Then wander into the forest of huge buildings at the lower end of Manhattan, stray down canyons with walls of towering structures that race skyward up, up, up until you become dizzy, looking. You feel like a pigmy amid the mammoth towers that stretch orderly ranks in every direction. The profusion of bigness humbles and awes you. You are overpowered."

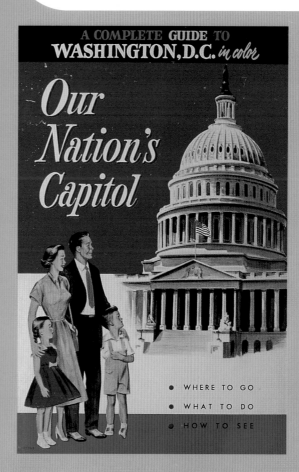

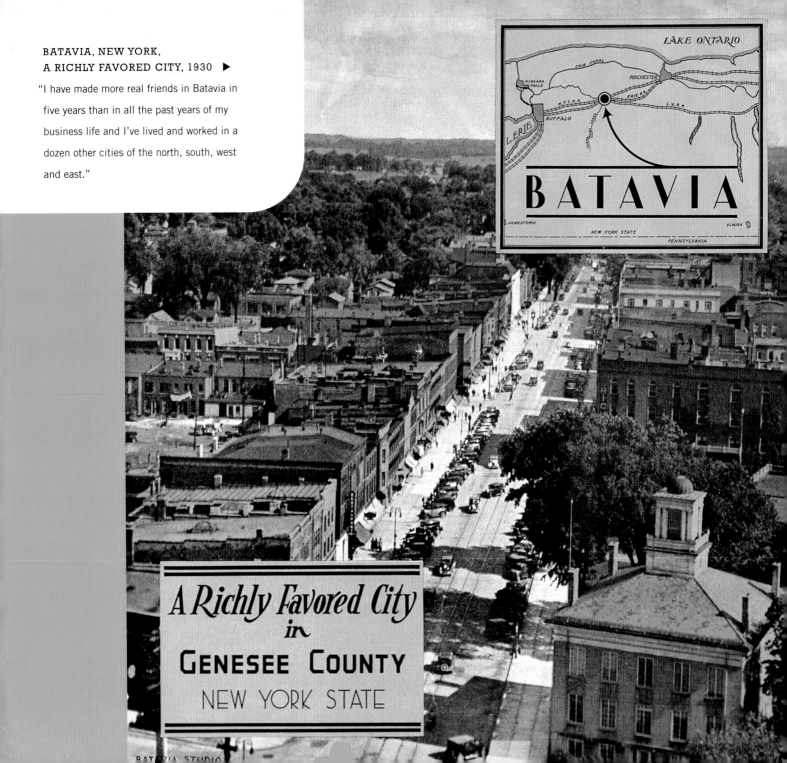

BATAVIA, NEW YORK,
A RICHLY FAVORED CITY, 1930 ▶

"I have made more real friends in Batavia in five years than in all the past years of my business life and I've lived and worked in a dozen other cities of the north, south, west and east."

LAKE ONTARIO

ERIE CANAL

ROCHESTER

NIAGARA FALLS

N.Y.C.R.R.

ERIE R.R.

L.V.R.R.

L.ERIE

BUFFALO

BATAVIA

JAMESTOWN

ELMIRA

NEW YORK STATE

PENNSYLVANIA

A Richly Favored City
in
GENESEE COUNTY
NEW YORK STATE

BATAVIA STUDIO

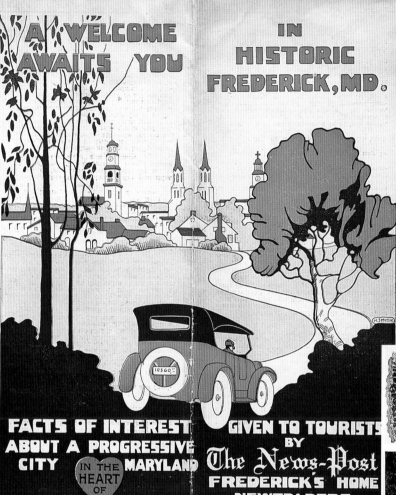

A WELCOME AWAITS YOU IN HISTORIC FREDERICK, MD.

FACTS OF INTEREST GIVEN TO TOURISTS ABOUT A PROGRESSIVE CITY IN THE HEART OF MARYLAND BY The News-Post FREDERICK'S HOME NEWSPAPERS

Delaware

An historical gem set between bay and ocean, with ancient churches, quaint pre-Revolutionary towns, and farms unsurpassed for fertility.

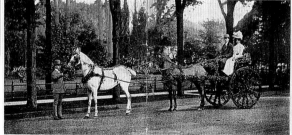

Grand Floral Ball, Sept. 3d Reception & Fireworks Sept. 5th 1900

Saratoga Floral Fete Floral Parade and Carnival Sept. 6th 1900

LIBERTY, NEW YORK, 1902–1903

"Statistics show that the county of Sullivan has the lowest death rate of any county in New York State. The natives of this section are sturdy and strong, the average man of sixty having the appearance of a man not over forty-five years old."

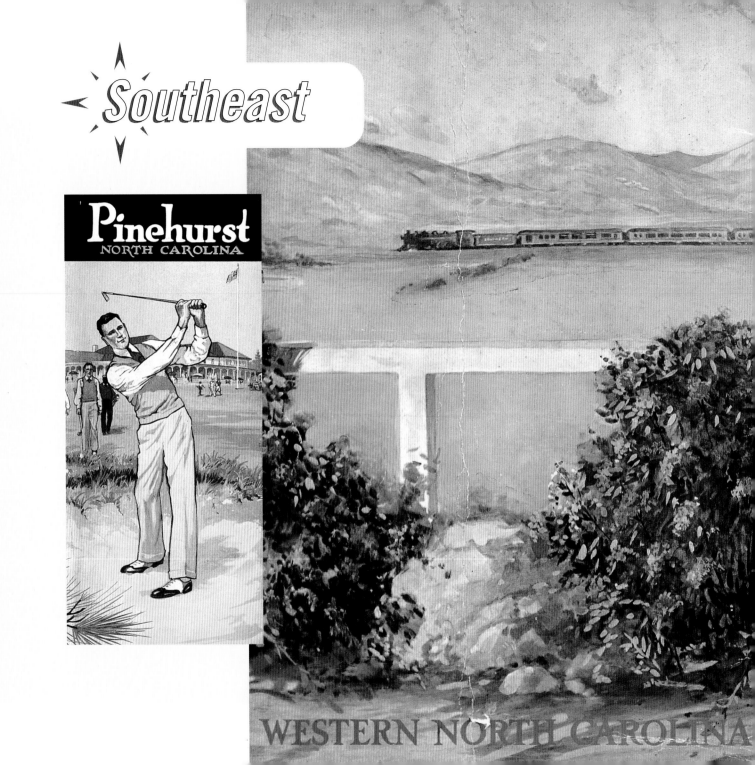

Southeast

Pinehurst
NORTH CAROLINA

WESTERN NORTH CAROLINA

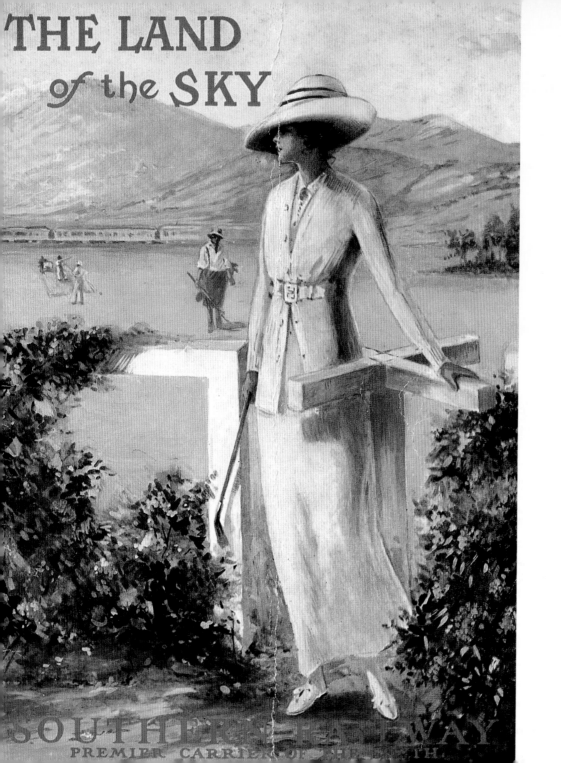

THE LAND
of the SKY

SOUTHERN RAILWAY
PREMIER CARRIER OF THE SOUTH

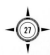

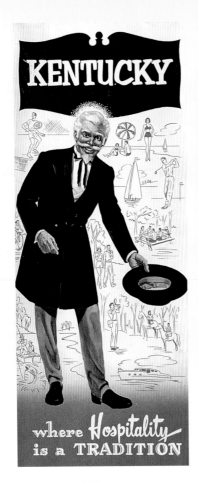

KENTUCKY

where *Hospitality* is a TRADITION

BLUE GRASS TOURS, 1926

"To no other person in the world is the love of home and native land so great as it is to the Blue Grass Kentuckian. Stephen Foster did not merely give his poetic fancy free rein when he penned the immortal words of 'My Old Kentucky Home.' But he expressed the deep and sincere feeling of all patriated Kentuckians, who are inarticulate when it comes to boasting the charms of a country that once seen, needs no press agent to proclaim its work."

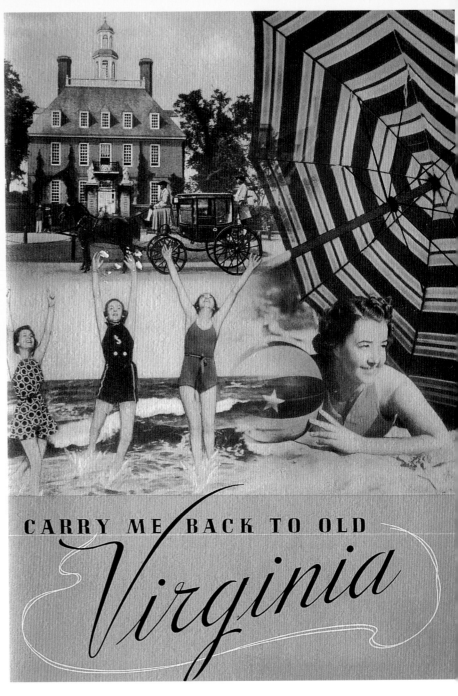

CARRY ME BACK TO OLD *Virginia*

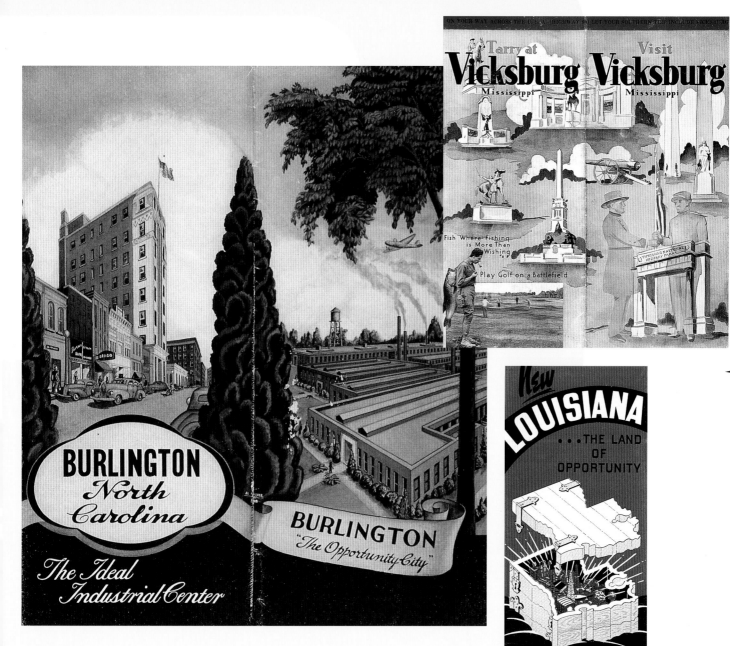

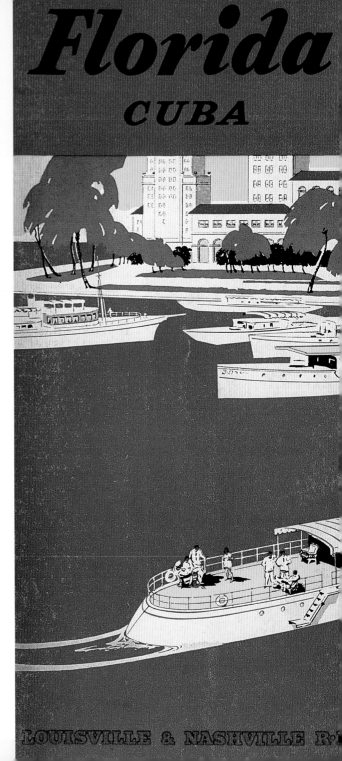

ORLANDO: THE CITY BEAUTIFUL, 1930

"Wake up on a clear, bright morning in Orlando and wander along
a quiet street past rows of great moss-hung oaks. Stroll over to your
favorite neighborhood lake, there are 32 of them within city bound-
aries, 800 more nearby, and settle down on a comfortable seat for
hours of reverie and relaxation. Colonial houses, well-kept lawns
and luxuriant tropical shrubbery form the perfect setting for your
dreamy, idle mood. You can be contented, restful surrounded by
the natural beauty of such a community."

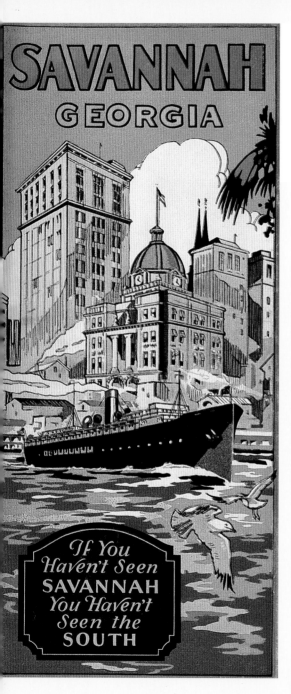

GEORGIA, 1933

"Enough to say that Georgia is pretty nearly that ideally all-round playground which the ambitious resort literature describe."

Franklin Roosevelt

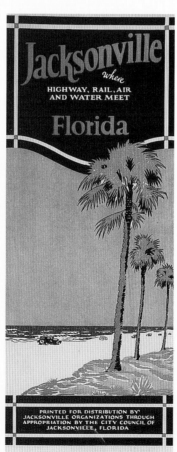

OUTWITTING WINTER IN THE
CITIES OF THE SUN, 1935

"From the practical standpoint, too, the Miami area is ideal for those of advancing years. Medical men agree that the equable, sea level, salt air climate is a large factor in combating arterial-sclerosis, high blood pressure and similar ailments, and the many hale and hearty oldsters who have found a snug harbor here for later life will bear out the doctors endorsement of healthy outdoor living in the Cities of the Sun."

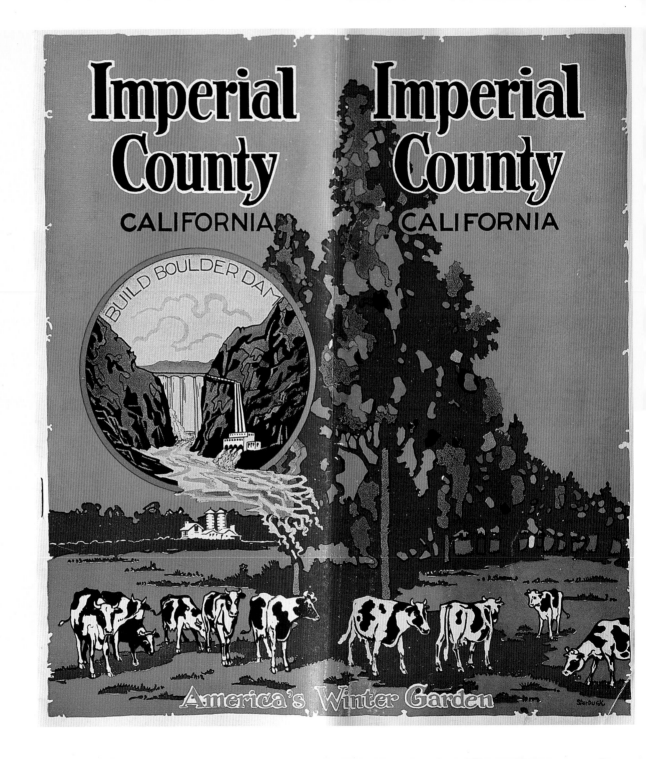

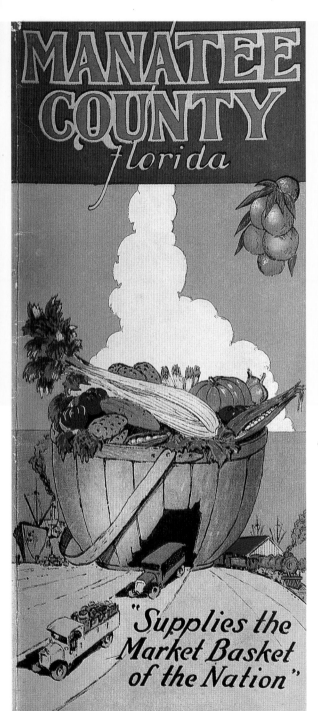

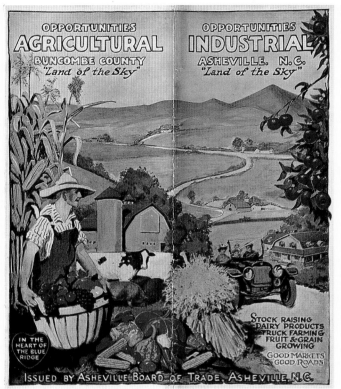

YANKTON: MOTHER CITY OF THE DAKOTAS, c. 1930

"From the rich soil of the 'Valley of Yankton' comes wealth which helps to fill the breadbaskets of the world. The traveler who journeys through Yankton traverses one of the most fertile farming regions of the middle-west, hears the familiar sounds of nature's own symphony, the lowing of contented cattle, the hum of the grain binder, the thump thump of gold ears on the back-board, the lazy grunting of fat porkers, the shrill cackling of farm-yard flocks."

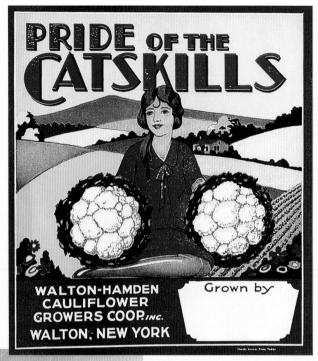

PRIDE OF THE CATSKILLS

WALTON-HAMDEN CAULIFLOWER GROWERS COOP. INC. WALTON, NEW YORK

Grown by

NORTH DAKOTA

RAPID CITY, SOUTH DAKOTA, 1928

"Hog raising has trebled in the Rapid City region during the past three years. Hogs make the most economical gain on alfalfa, the climate is excellent and hog cholera is as yet a stranger."

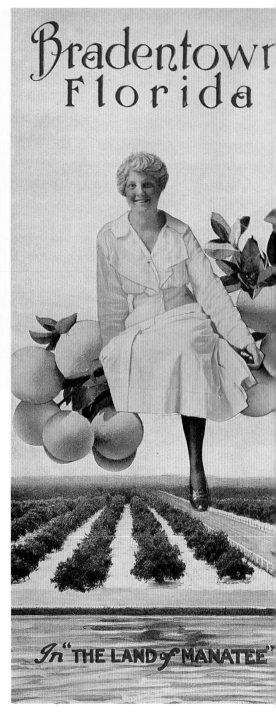

Bradentown Florida

In "THE LAND of MANATEE"

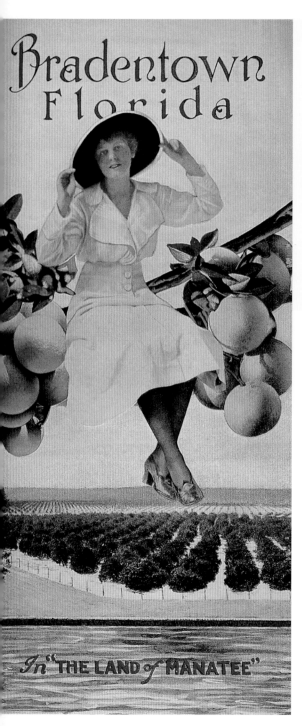

Bradentown
Florida

In "THE LAND of MANATEE"

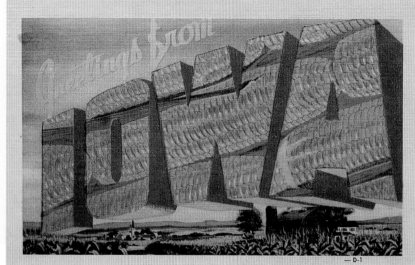

— D-1

THE STATE OF IOWA WELCOMES YOU, 1950

"'The Iowa Corn Song': The 'Iowa Corn Song,' familiar all over the United States by use at Shrine, Legion, and other conventions, is a genuine favorite with Iowa people. It was first used in 1912 by Za-Ga-Zig Temple Shriners of Des Moines at a convention in Los Angeles. . . . The chorus is a pepper-upper and the raising of the right arm when singing the last line, adds the touch that sells it everywhere.

Chorus:

> We're from Ioway, Ioway;
> State of all the land,
> Joy on every hand;
> We're from Ioway, Ioway,
> That's where the tall corn grows."

Midwest

CHICAGO: THE VACATION CITY, 1931

"There are those who have said Chicago is without 'atmosphere,' and so they have traveled afar seeking that intangible and elusive quality—now on The Strand of London, again in the Quartier Latin of Paris, the Louvre or in the Luxembourg Gardens, again Unter den Linden in Berlin, or on some exotic Oriental Bund, and they have come back, and have found it—in Chicago. . . . Chicago with its gleaming strands of beach, its broad boulevards, its inviting parks, its Far East lagoons, its palatial hotels—their dining rooms set at the very edge of the 'lake that is an ocean.'"

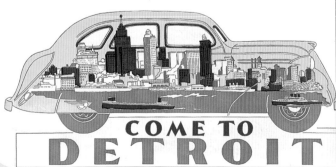

COME TO DETROIT

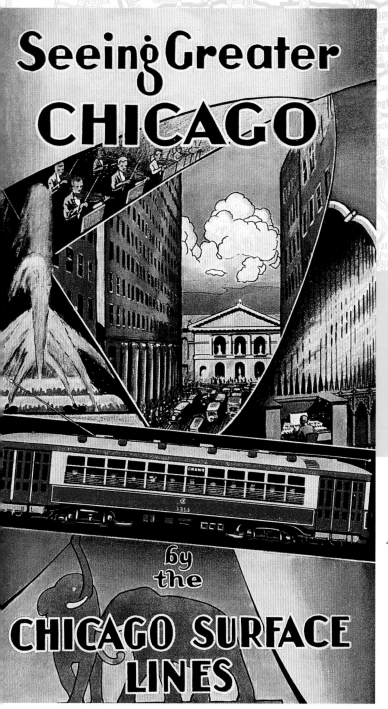

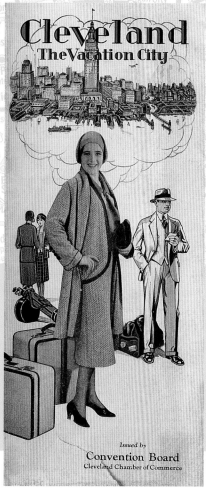

▲

CLEVELAND, THE VACATION CITY, 1930

"CLEVELAND is different from most other places which attract summer vacationists because the Cleveland recreation district offers every variety of city and out-door amusement. You can stay at a metropolitan hotel and eat amid dinner jackets and evening gowns or live in a tent and prepare your food by camp-fire; hear nationally known orchestras or strum your own ukulele on the beach; see big league baseball and go to the theater or fish and watch the moon set over Lake Erie."

VISITORS FIND REAL HOSPITALITY AT OBLONG, ILLINOIS, c. 1960

"The way Oblong was named is a good story. Originally, the city was called Henpeck—like in a husband. But, understandably enough, some citizens took exception to being known as 'Mr. so-and-so' from Henpeck. Thus it was that when Henpeck came to be incorporated it was voted to rename the city Oblong (because of the physical dimensions of the city). And the vote, it is reported, was unanimous."

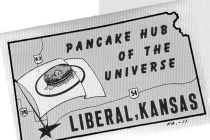

LIBERAL, KANSAS, c. 1950

"Liberal is world famous as the 'Pancake Hub of the Universe' by the international pancake day race between the housewives of Liberal and Olney, England, held each year on Shrove Tuesday."

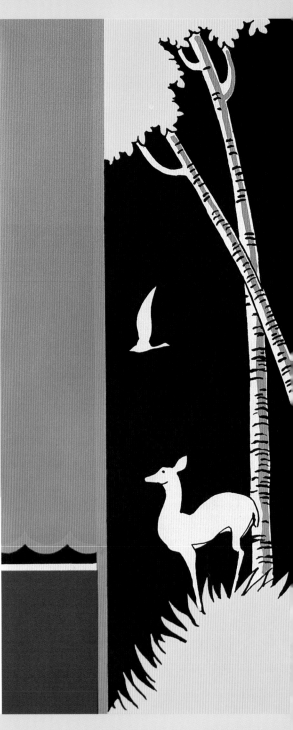

IRON
COUNTY
WISCONSIN

WISCONSIN'S
Vacation
PARADISE

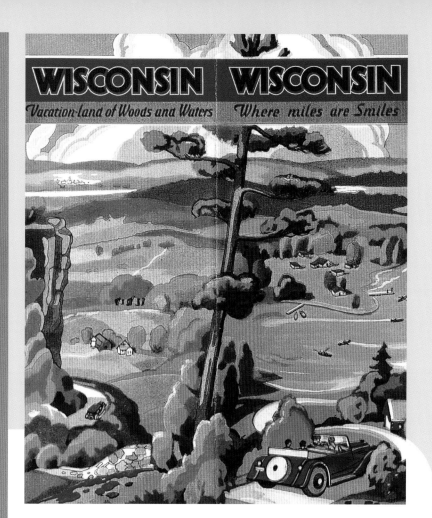

WISCONSIN
Vacation-land of Woods and Waters

WISCONSIN
Where miles are Smiles

TOMAHAWK, WISCONSIN, c. 1965

"WHERE TO SEE BEAR: Bear can be seen at the Wilson Town Dump—County Trunk CC—4 miles—watch for sign on rt. Turn right one-quarter mile. Also at the Bradley Town Dump on Tannery Road. The Conservation Dept. warns to stay in your cars while you are watching the bear."

"GO TO HELL", MICHIGAN, c.1970

"19 miles northwest of Ann Arbor . . . lies a tiny community that time will never forget: Hell, Michigan. . . . Potawattomie Trail originates at Bruin Lake Scout Camp and traverses fourteen miles to Hell and back. . . . A trip thru the Devil's Spell is a must and the Den of Antiquity features friendly but sinfully low prices for their many novelties, gifts and antiques. You can mail a snowball from Hell even on the hottest day of summer."

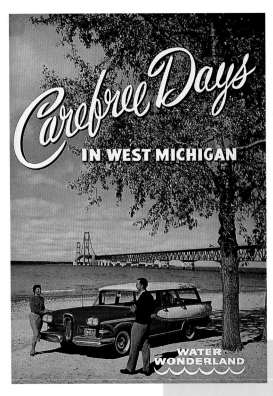

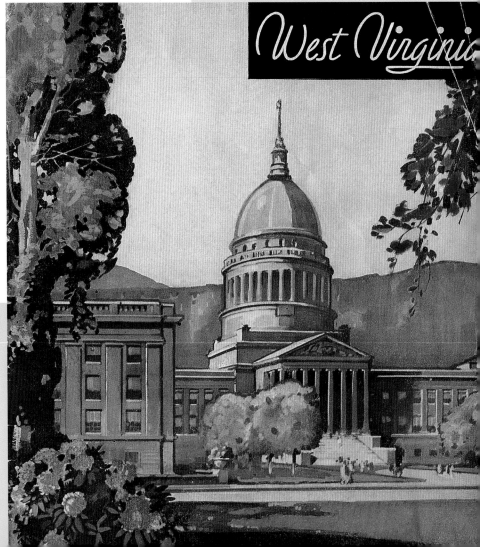

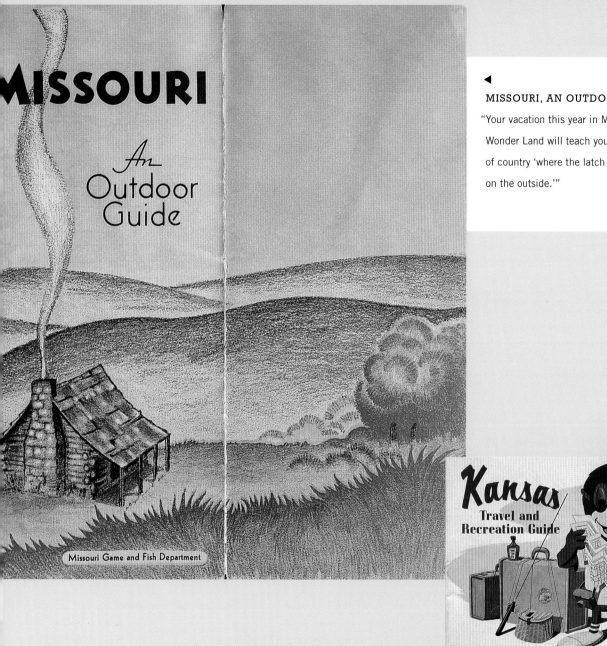

MISSOURI

An
Outdoor
Guide

Missouri Game and Fish Department

◄

MISSOURI, AN OUTDOOR GUIDE, c. 1935

"Your vacation this year in Missouri's outdoor Wonder Land will teach you the full appreciation of country 'where the latch string always hangs on the outside.'"

Kansas
Travel and
Recreation Guide

CHAMBER OF COMMERCE
ARKANSAS CITY, KANSAS

Southwest

ARIZONA WELCOMES YOU, c. 1935 ▶

"Throughout the innumerable, sun-lit miles that are Arizona, the traveler finds today countless signs of a lost people whose story is told in ancient ruins. Here history that has never been written speaks in silent tongue. Where did they come from? Where did they go? These ancient ones!"

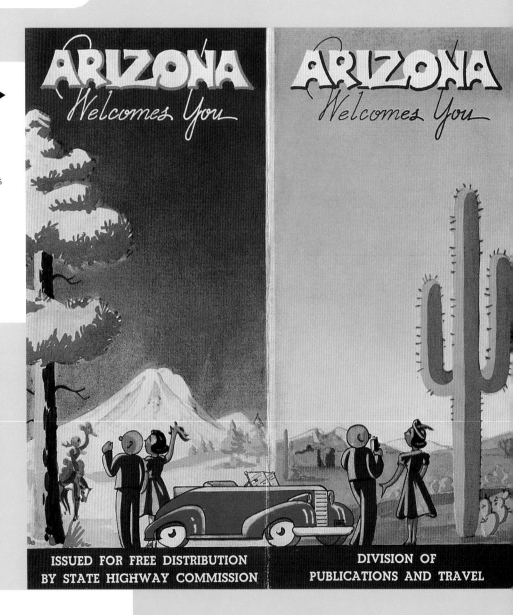

ARIZONA
Welcomes You

ARIZONA
Welcomes You

ISSUED FOR FREE DISTRIBUTION
BY STATE HIGHWAY COMMISSION

DIVISION OF
PUBLICATIONS AND TRAVEL

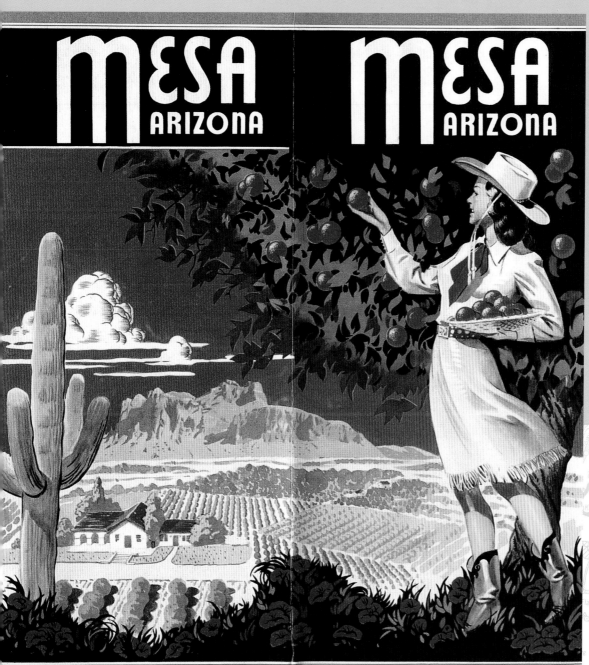

MESA
ARIZONA

MESA
ARIZONA

IN ARIZONA'S VALLEY OF THE SUN IN ARIZONA'S VALLEY OF THE SUN

TUCSON
ARIZONA

43

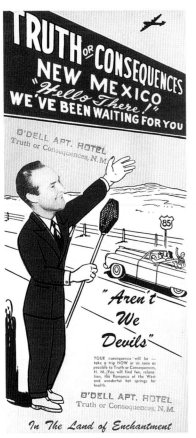

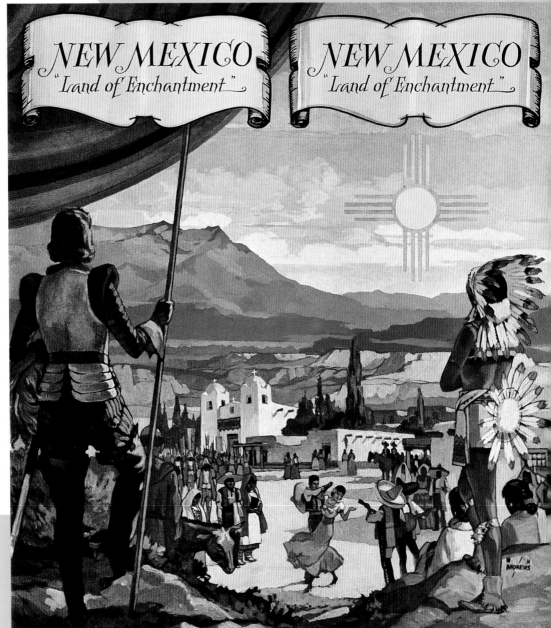

NEW MEXICO
"Land of Enchantment"

NEW MEXICO
"Land of Enchantment"

ALBUQUERQUE

◀

ALBUQUERQUE, 1925

"In a majority of cases coming to Albuquerque from a low altitude will be noted an increase of hemoglobin and blood count which simply means an increase in the red cells in the blood."

SAN ANTONIO, c. 1930

"I always told you there was just three
towns in the whole of America that
was different and distinct. . . . New
Orleans, Frisco, and San Antonio.
Each has got something that even the
most persistent Chamber of Commerce
can't standardize."

Will Rogers

EL PASO EL PASO

Sunshine Playground of the Border Sunshine Playground of the Border

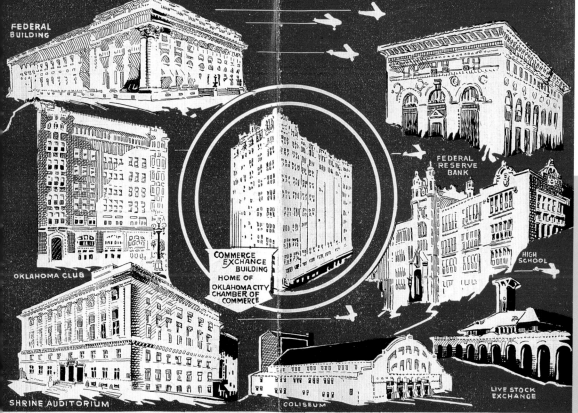

OKLAHOMA CITY

A VISITOR'S GUIDE
WHERE TO GO AND HOW TO GET THERE

FEDERAL BUILDING

OKLAHOMA CLUB

FEDERAL RESERVE BANK

HIGH SCHOOL

COMMERCE EXCHANGE BUILDING
HOME OF OKLAHOMA CITY CHAMBER OF COMMERCE

SHRINE AUDITORIUM

COLISEUM

LIVE STOCK EXCHANGE

ISSUED BY
OKLAHOMA CITY
CHAMBER of COMMERCE
COURTESY, WESTERN BANK & OFFICE SUPPLY CO.

OKLAHOMA CITY

A VISITOR'S GUIDE
WHERE TO GO AND HOW TO GET THERE

ISSUED BY
OKLAHOMA CITY
CHAMBER of COMMERCE
COURTESY, WESTERN BANK & OFFICE SUPPLY CO.

OKLAHOMA: THE "SOONER" STATE, 1933

"Here rows of illuminated oil derricks gleam like fantastic Christmas trees in the night; blossoming fruit, locust, and catalpa trees exquisitely perfume the air in the springtime; rivers wind through oak, gum, pine, and black-jack forests; tender grass and young crops make emerald the gently rolling hills."

OIL CAPITOL
TULSA
OKLAHOMA

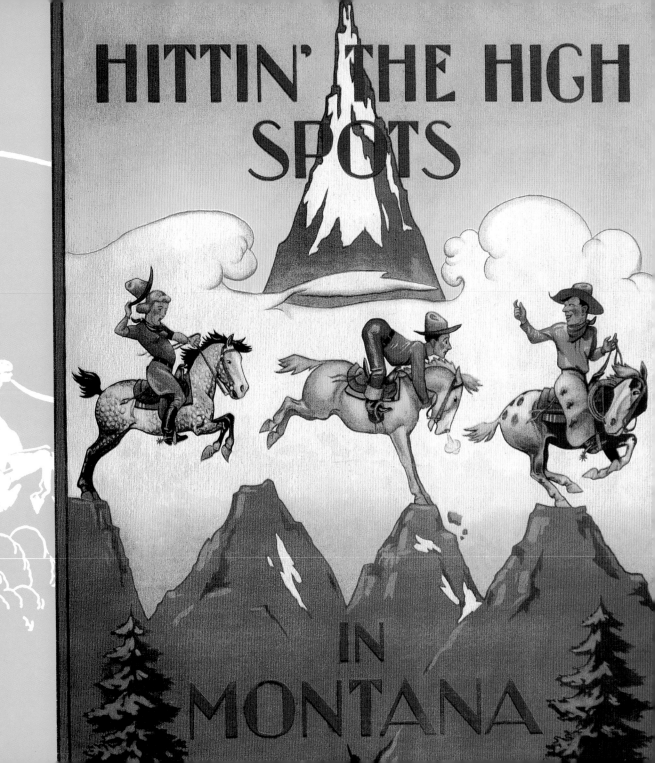

COWBOYS ✶

HITTIN' THE HIGH SPOTS

IN MONTANA

CASPER

the HUB OF WYOMING

CASPER

Gateway to THE LAST FRONTIER

WHEN MEN WERE MEN

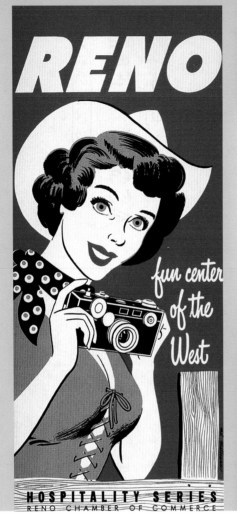

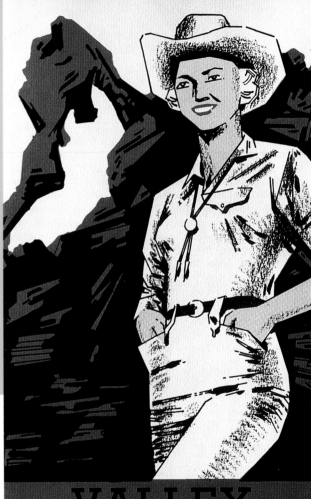

SOUTH DAKOTA, LAND OF ENCHANTMENT, 1938

"Many personalities have passed across the pages of South Dakota's history. The lives of some have been frequently romanced and their names are household words. The names of Wild Bill Hickok, Calamity Jane, Deadwood Dick, and others are well known. Some of those who knew them and took part in the stirring events that crowded the early period of the Gold Rush are still living and spin their tales for the vacationist who is lucky enough to find them in a talkative mood."

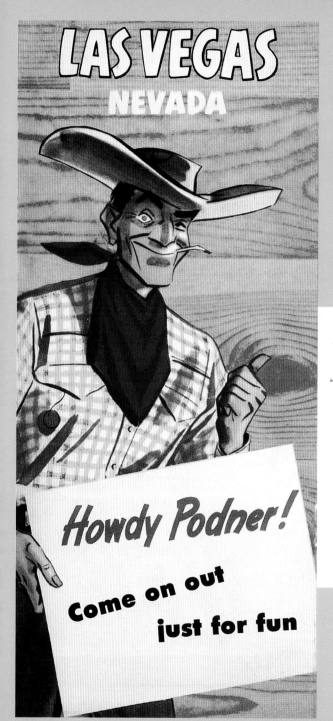

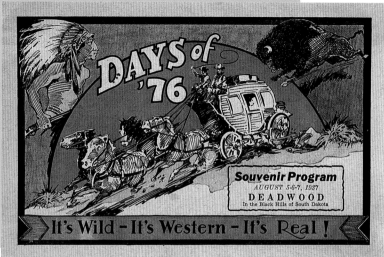

◄

LAS VEGAS AND BOULDER DAM, NEVADA, 1939

"You'll enjoy unique pastimes available under Nevada's liberal laws. Las Vegas is still a frontier town—a real western town where Saturday and other nights the blithe cowboy off the ranges and grizzled desert prospector mingle their laughter around the gaming tables. With them, enjoying the play, are writers, movie stars, directors, and other vacationists from all parts of the world—some here solely to recreate their energies in this amazing playland, others to take advantage of Nevada's 'modern' divorce and marriage laws."

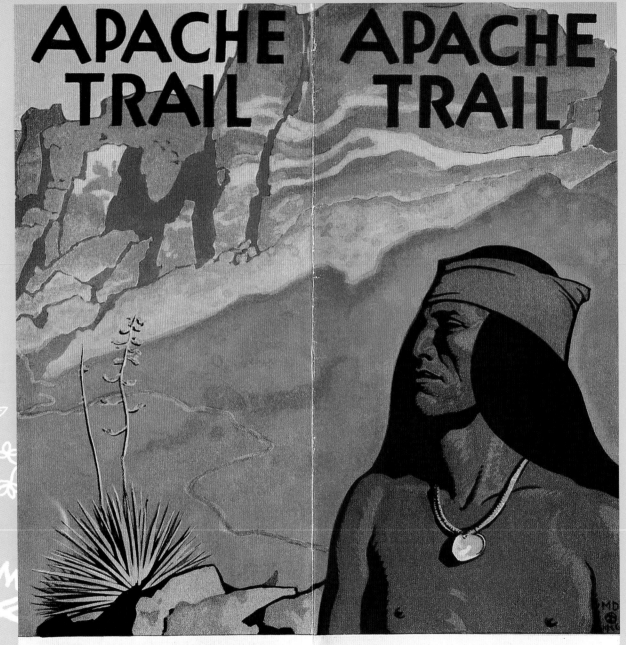

APACHE TRAIL

APACHE TRAIL

Southern Pacific

Southern Pacific

INDIANS ✪

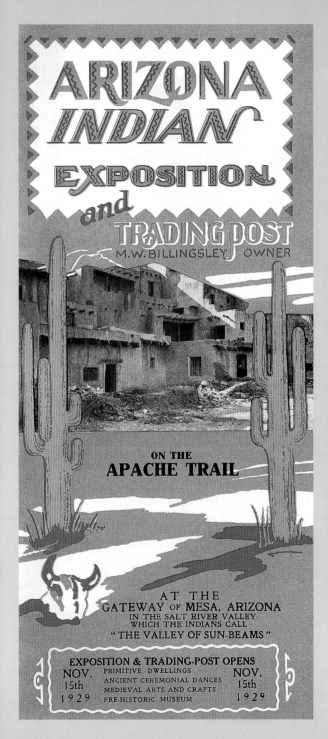

ARIZONA
INDIAN
EXPOSITION
and
TRADING POST
M.W. BILLINGSLEY OWNER

ON THE
APACHE TRAIL

AT THE
GATEWAY OF MESA, ARIZONA
IN THE SALT RIVER VALLEY
WHICH THE INDIANS CALL
"THE VALLEY OF SUN-BEAMS"

EXPOSITION & TRADING-POST OPENS
NOV. NOV.
15th PRIMITIVE DWELLINGS 15th
1929 ANCIENT CEREMONIAL DANCES 1929
 MEDIEVAL ARTS AND CRAFTS
 PRE-HISTORIC MUSEUM

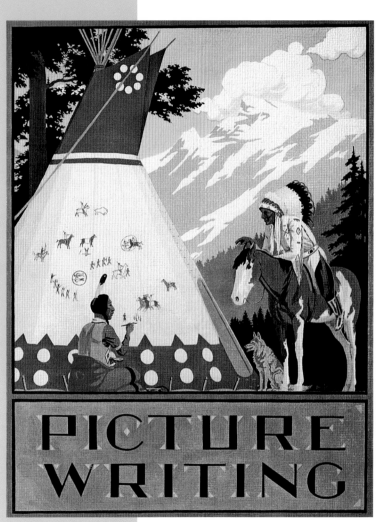

PICTURE
WRITING

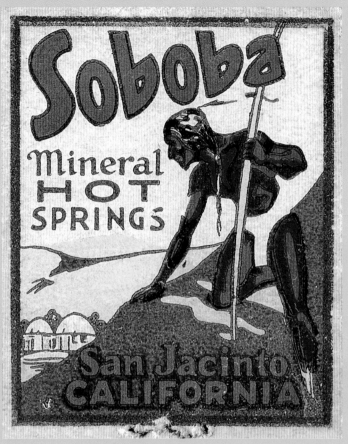

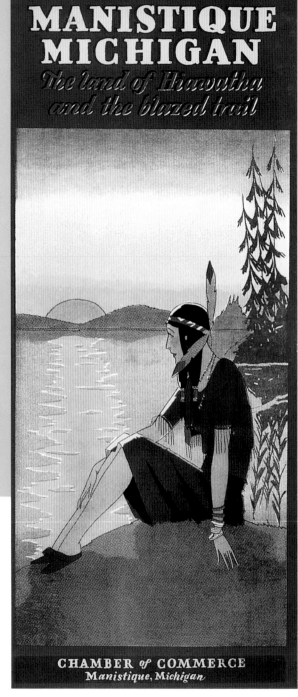

TOURIST GUIDE OF MENOMINEE COUNTY, c. 1940

"The Menominee Indians left Menominee in 1854 when the federal government offered them a reservation along the Wolf River in Wisconsin. But they left their spirit stone behind. It is now at the Michigan State Highway Department tourist information lodge. The Indians believed that if you made a wish over the stone you would get your wish."

The ADIRONDACKS

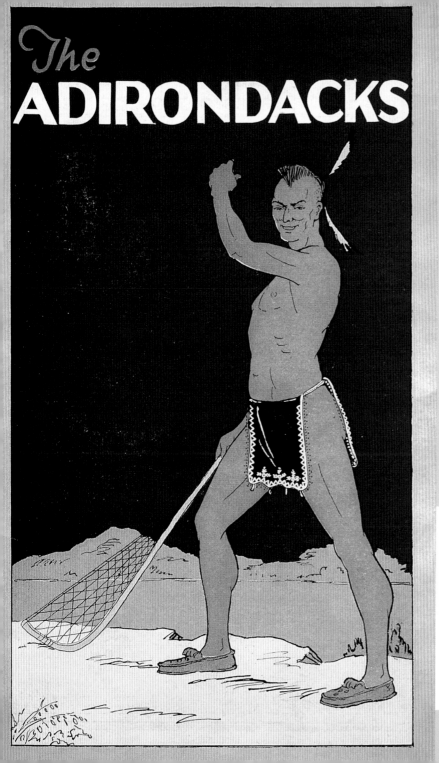

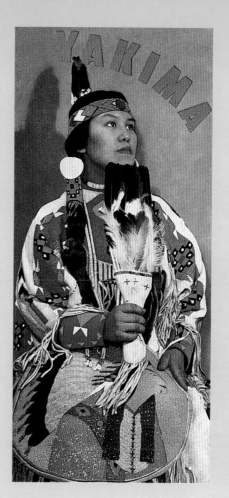

WISCONSIN, 1940

"Back in the days before the white man discovered this beautiful country, many places in what we now call Wisconsin were summering spots for the roving Indians. They, like their white brothers today, sought this cool, green land of woods and waters for rest and relaxation."

Rocky Mountain West

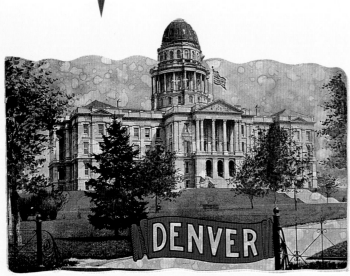

DENVER

TRINIDAD COLORADO, 1922

"Trinidad is a busy, bustling hive of industry—
its stores are metropolitan, the hotels and
banks prosperous, its newspapers progressive,
its schools modern, its people happy and
contented. . . . You'll find a hearty welcome
here—our motto is 'Smile and Speak First.'"

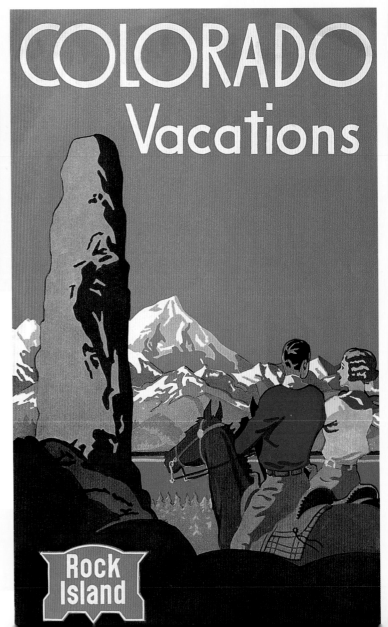

COLORADO
Vacations

Rock
Island

See **DENVER**

PIKES PEAK AUTO LIVERY
Albany Hotel
DENVER, COLORADO

HAYWARD

Denver is America's only city with 20,860 acres of scenic Mountain Parks embracing more than 100 miles of paved highways.
(Drive West from Denver—20 minutes and you're in the Rockies)

Nature's solid rock sounding board, acoustically perfect, inspired this gigantic, new outdoor theatre in Denver's Red Rocks Park.
(Over a wide highway—only 15 minutes from Denver)

Salt Lake City

PUBLISHED BY SALT LAKE CITY PASSENGER ASSOCIATION

SEE *Everything* IN
MONTANA

PUBLISHED BY THE MONTANA STATE HIGHWAY COMMISSION

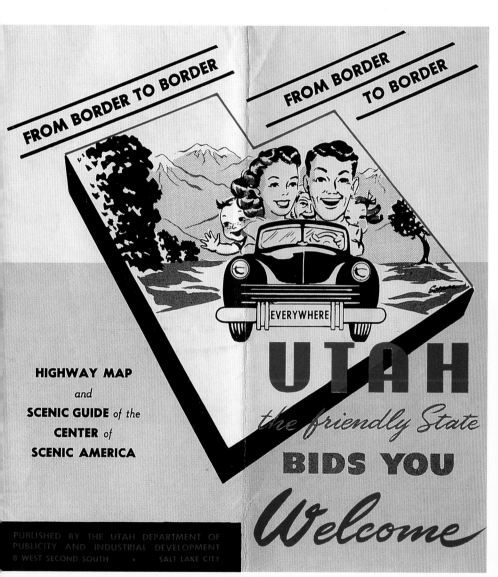

FROM BORDER TO BORDER

FROM BORDER TO BORDER

EVERYWHERE

UTAH
the friendly State
BIDS YOU
Welcome

HIGHWAY MAP
and
SCENIC GUIDE *of the*
CENTER *of*
SCENIC AMERICA

PUBLISHED BY THE UTAH DEPARTMENT OF PUBLICITY AND INDUSTRIAL DEVELOPMENT
8 WEST SECOND SOUTH • SALT LAKE CITY

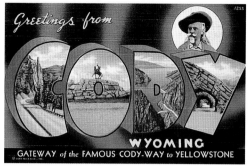

Greetings from **CODY** **WYOMING**
GATEWAY *of the* FAMOUS CODY-WAY *to* YELLOWSTONE

CODY, WYOMING, THE LAST
OF THE BEST OF THE ROARING
OLD WEST, c. 1940

"Vivid in the minds of those who have ever
experienced a Cody Stampede is Wolfville, old
time Western dance hall, where it's always
'your night to howl.'"

59

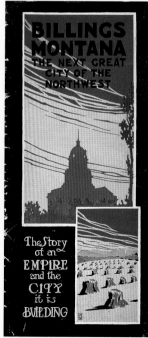

**BILLINGS
MONTANA**
**THE NEXT GREAT
CITY OF THE
NORTHWEST**

The Story
of an
EMPIRE
and the
CITY
it is
BUILDING

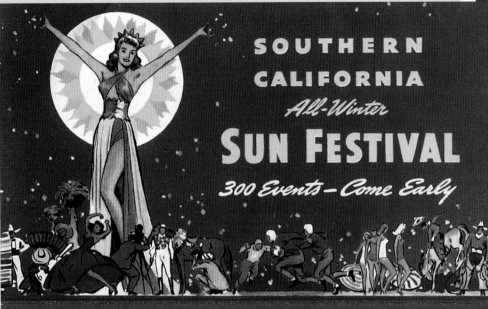

SOUTHERN CALIFORNIA
All-Winter
SUN FESTIVAL
300 Events — Come Early

SUN FESTIVAL
FACTS

November, 1941 — April, 1942

SOUTHERN
California
all the
YEAR

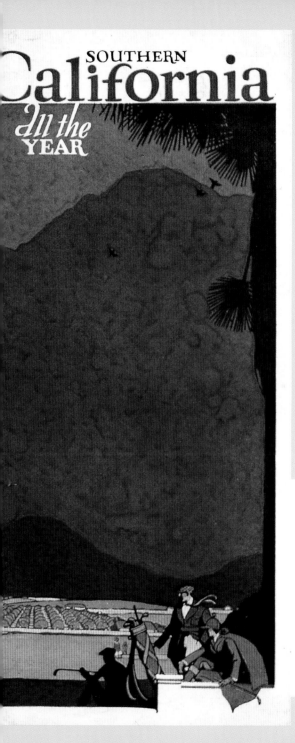

SOUTHERN
California
all the
YEAR

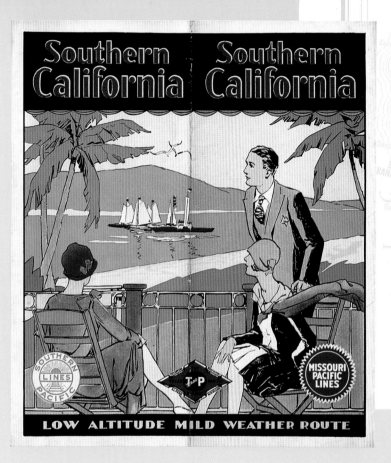

CALIFORNIA WELCOMES YOU, 1923

"Suppose some Southern California native—either natural or adopted—
becomes so highly charged with enthusiasm over the glories of his home
land that he either has to sing or bust—what does he do? He sings, of
course. He sings out loud. He sings of a land of milk and honey and lotus
blossoms. He sings of azure days and balmy nights, of silvery moons and
myriad stars of molten gold, of purple wavelets caressing palm-fringed
beaches."

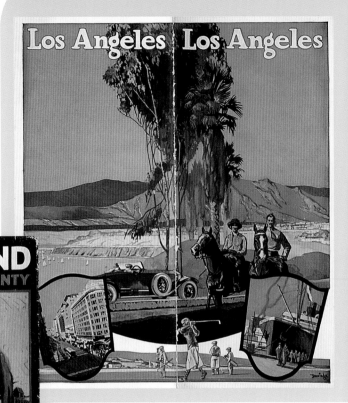

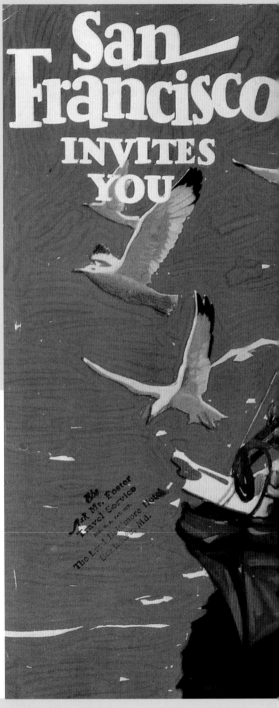

LONG BEACH, 1933

"Strategically located just 20 miles from Los Angeles and stretching out in a vast panorama of glorious charm, with the spires of its metropolitan skyline rising majestically along a beautifully terraced bluff and matchless bathing strand, a forest of oil derricks encircling the horizon, snow-capped mountain peaks casting their shadows in the distance and the giant warships of the United States Battle Fleet anchored off shore, Long Beach is the natural gateway to Southern California's endless allurements."

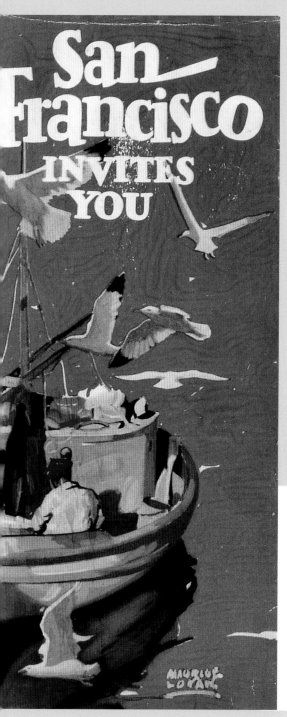

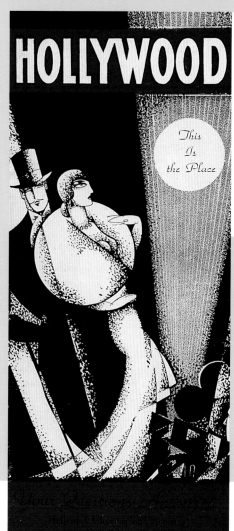

**SAN FRANCISCO'S FAMOUS
NIGHT-LIFE PARTY, c. 1955**

"Painting San Francisco red, or even a light pink, comes high these days. So it may be of more than passing interest to Bay Area visitors and residents alike that a rather neat paint job can be done for only $9.50 per capita—tips parking, drinks, and floor show included."

YOU'LL ENJOY SAN FRANCISCO, 1930

"Deep salt water, restless with the tides, surrounds San Francisco on three sides. You feel the sea in San Francisco as you would on a ship in mid-ocean. To visit San Francisco is to go to sea on dry land."

OREGON
PRIMER

MOUNT HOOD *from the Hood River Valley* OREGON

FRUITS GRAIN DAIRIES

LUMBER MINES FISH

PUBLISHED BY
PORTLAND
CHAMBER OF COMMERCE
PORTLAND OREGON

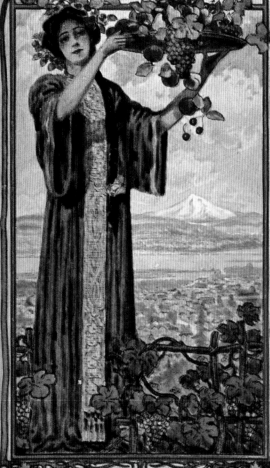

OREGON
PRIMER

FRUITS GRAIN DAIRIES

LUMBER MINES FISH

PUBLISHED BY
PORTLAND
CHAMBER OF COMMERCE
PORTLAND OREGON

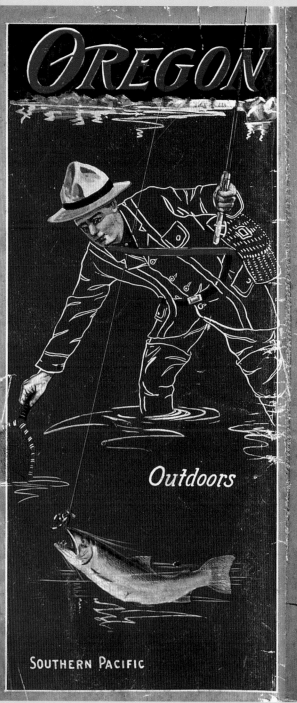

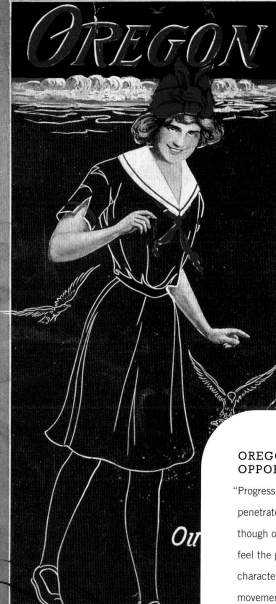

OREGON: THE LAND OF OPPORTUNITY, 1909

"Progress—splendid and enduring progress— penetrates the very air we breathe, and even though one might be blind or deaf he could feel the promise, the optimism that is characteristic of Oregon. A mighty, irresistible movement is under way for the development of this commonwealth."

ALASKA AND PACIFIC COAST CRUISES, 1940

"It is a land of romance, of mystery and infinite charm. Known to the world for its fabulous store of gold, its big game trophies, its silver, copper, fish, and furs, it is loved for its history and romance, intangibles not measured in terms of commerce."

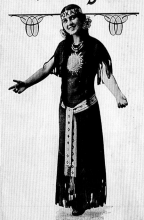

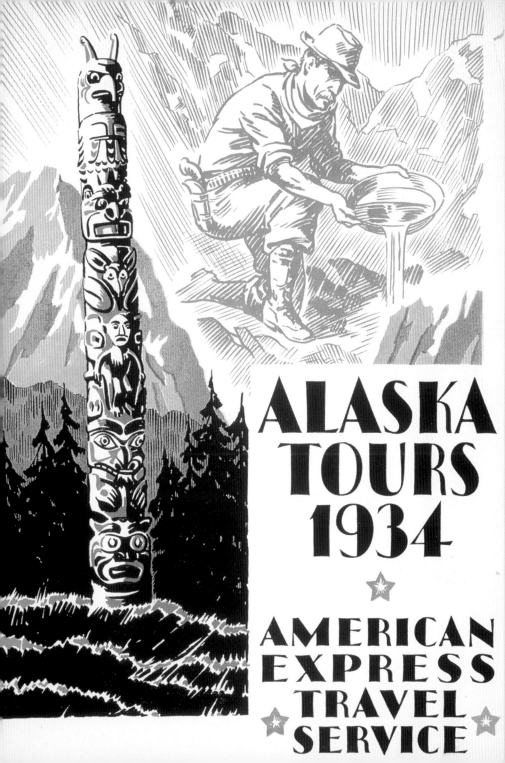

ALASKA TOURS 1934

★

AMERICAN EXPRESS TRAVEL SERVICE

Pocket Encyclopedia of **Alaska** the 49th State

Your reminder of **Westinghouse** *Lucy-Desi*

Wonderama Days

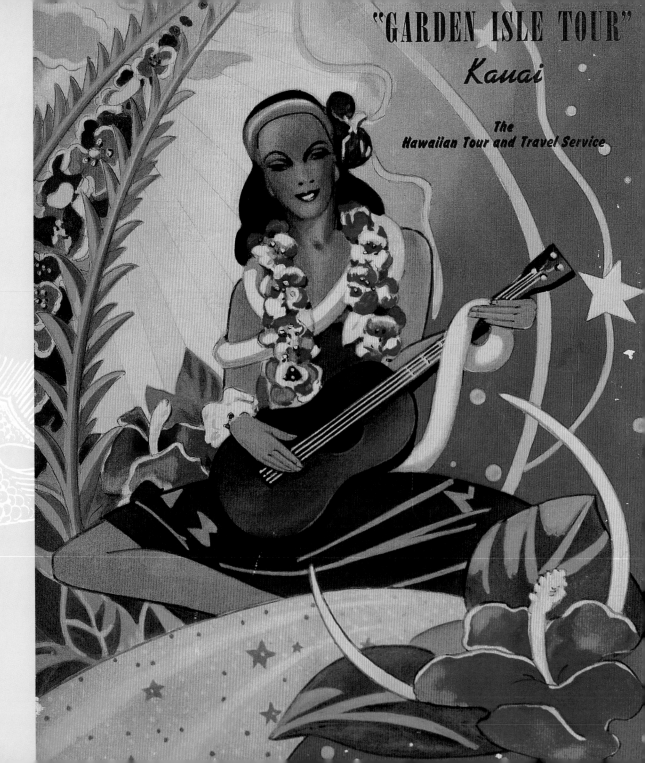

HAWAII

★

"GARDEN ISLE TOUR"

Kauai

The
Hawaiian Tour and Travel Service

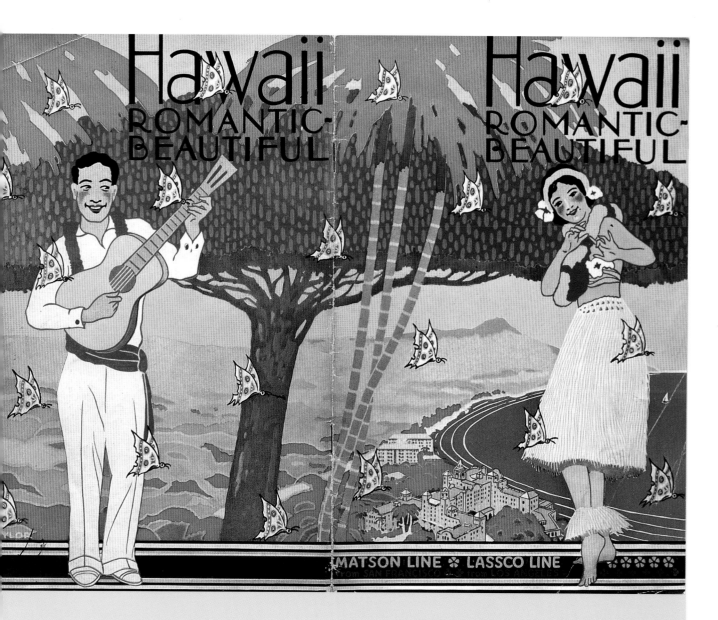

MATSON LINE ✣ LASSCO LINE
from SAN FRANCISCO ✣ from LOS ANGELES

HAWAII ROMANTIC...BEAUTIFUL, 1931

"Picture a cluster of enchanted islands, set in a sea bluer than blue, beneath a sky of flawless serenity . . . a gently-sloping strand where you may recline, fanned by soft breezes, lulled by the beat of the breakers over the reef. . . . Fancy royal palms, slender and stately, rising above the coral sands . . . a thousand kinds of sands . . . flowers everywhere, in glorious profusion: a thousand kinds of hibiscus, incense-sweet; poinciana regia, glowing like red flame. . . . You do not have to imagine all these delights! They are yours for the seeking. Fancy becomes reality, and in a span of time unbelievably brief."

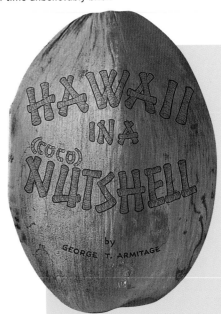

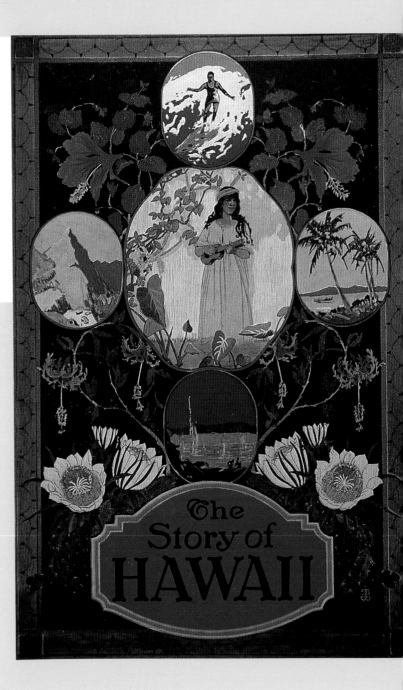

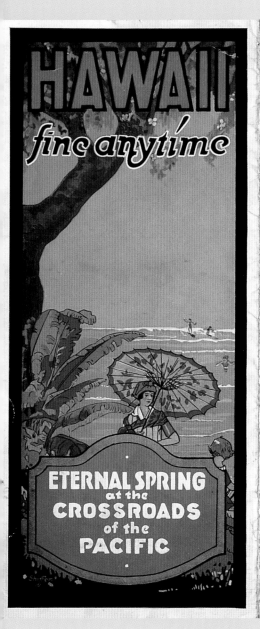

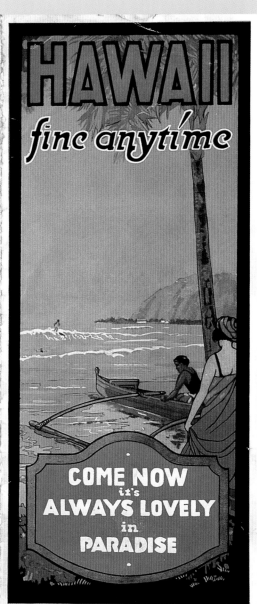

HAWAII, 1903

"No land in all the world has any deep, strong, charm for me but that one; no other land could so longingly and beseechingly haunt me sleeping and waking, through more than half a lifetime, as that one has done. Other things leave me, but it abides; other things change, but it remains the same."

Mark Twain

SEASIDE AMERICA

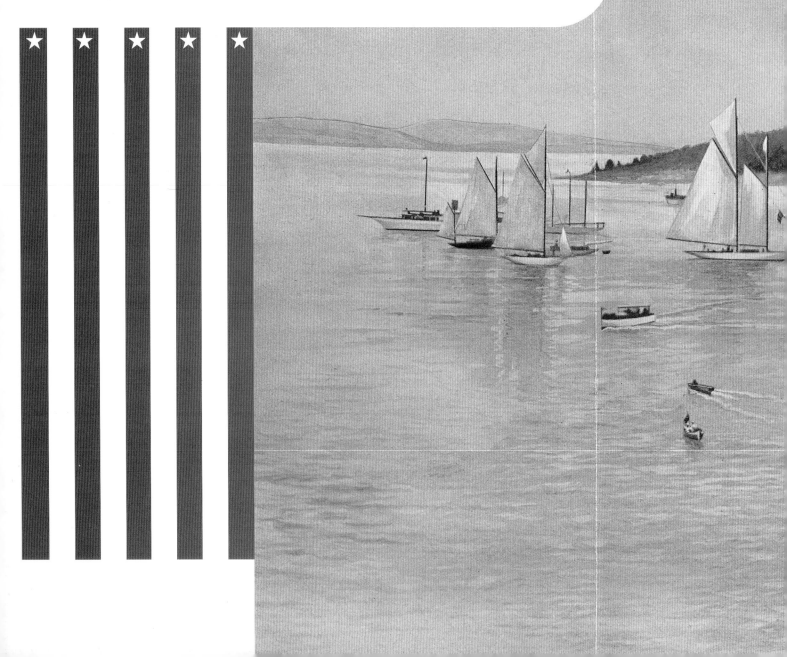

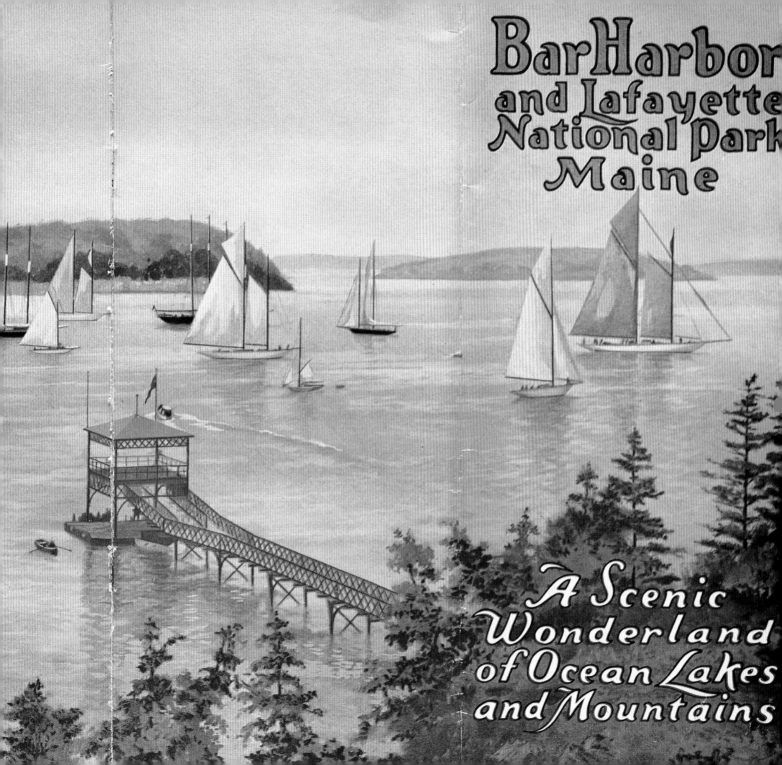

Atlantic Coast

What's FUN in FALMOUTH

FREE—Take One
Aug. 19 to 26, 1939

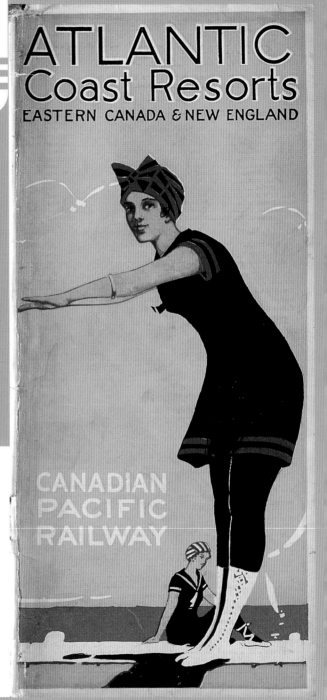

ATLANTIC
Coast Resorts
EASTERN CANADA & NEW ENGLAND

CANADIAN
PACIFIC
RAILWAY

ATLANTIC COAST RESORTS, 1916 ▶

"The waves lift and flash and boom into sounding, sundazzled, shifting depths—
the kiddies laugh and scamper and build Panama Canals along the wonderful
Atlantic shore—the gulls cry, wheeling through the infinite mazy silence that
lies, cloud-filled and slumberous, above all the pleasant summer turmoil. It's so
soul-satisfying to lie still on the warm sand that it seems wicked to move. And
yet, when you do shake off the sunbeam-fingers and sit up, the cool air slips over
your cheek and lifts your hair with so tinglesome a touch that motion—thrilled,
ecstatic, ozoneful—seems man's natural medium of expression. You want to
wheel with the gulls or jump joyously with the red-sand-shovelled kiddies!"

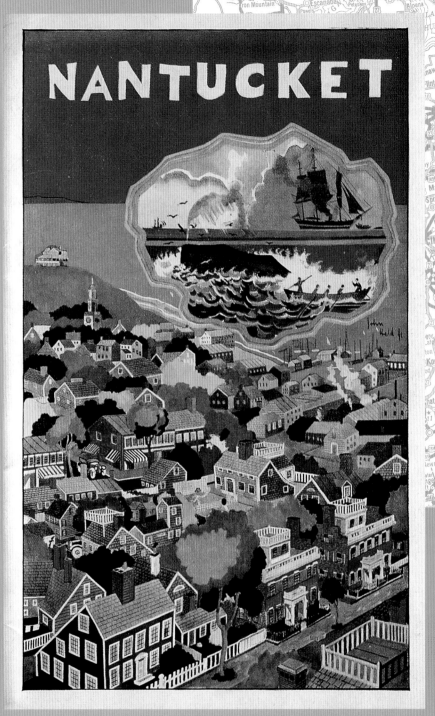

NANTUCKET

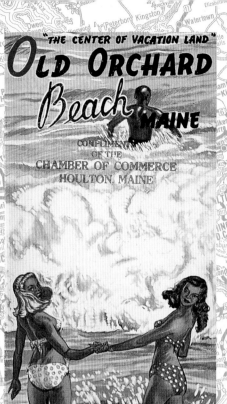

OLD ORCHARD
Beach MAINE

COMPLIMENTS
OF THE
CHAMBER OF COMMERCE
HOULTON, MAINE

CHAMBER OF COMMERCE
Old Orchard Beach, Maine

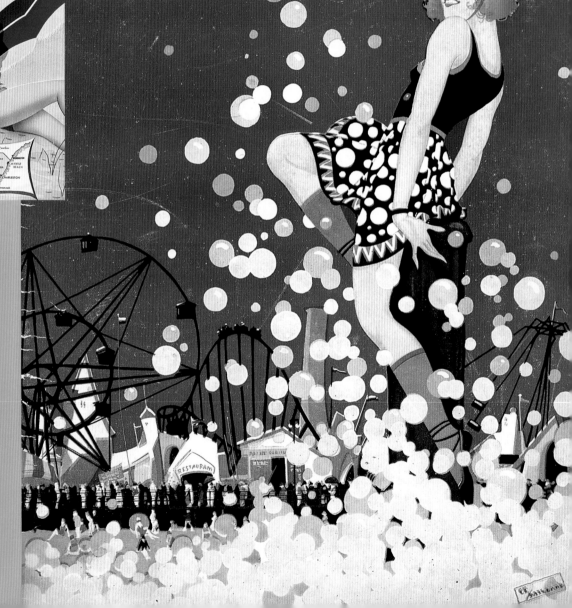

CONEY ISLAND

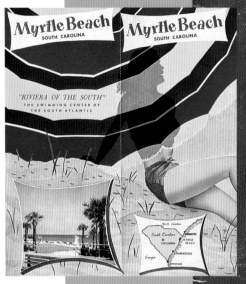

Myrtle Beach
SOUTH CAROLINA

Myrtle Beach
SOUTH CAROLINA

"RIVIERA OF THE SOUTH"
THE SWIMMING CENTER OF
THE SOUTH ATLANTIC

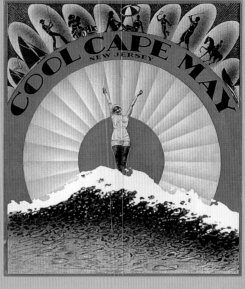

COOL CAPE MAY, NEW JERSEY, c. 1920

"In making a list of all the desirable qualities of your ideal City, the kind of place where you would like to live, to bring your family or to enjoy a vacation, and before making a total, add to this list the song of the Sea, the tang of salt air, the glorious sunrise greeting the morn and the gorgeous sunset at rest in the sea, the rustle of the breeze through the shady streets, the brilliant color of beautiful summer flowers—the sum total presents to you a good picture of Cape May City."

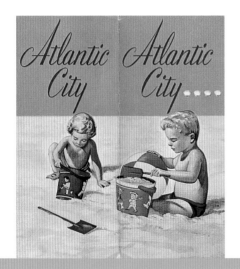

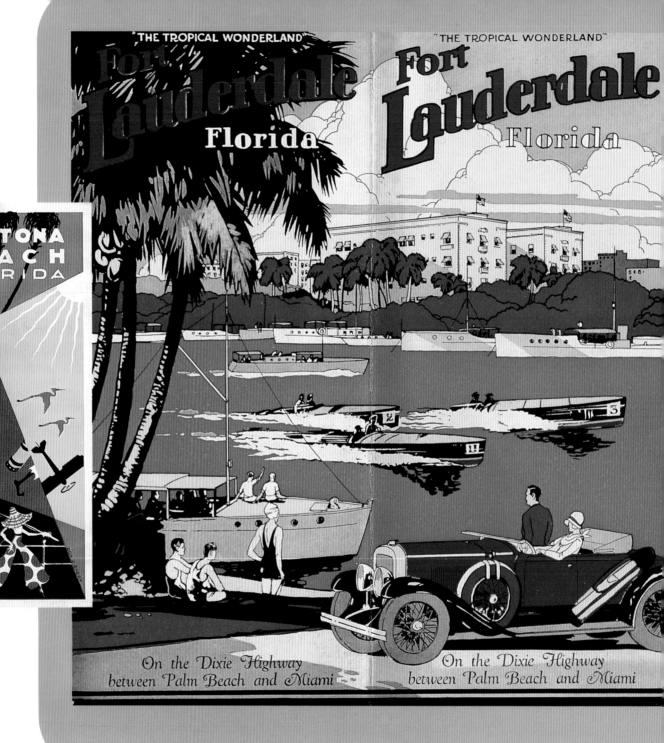

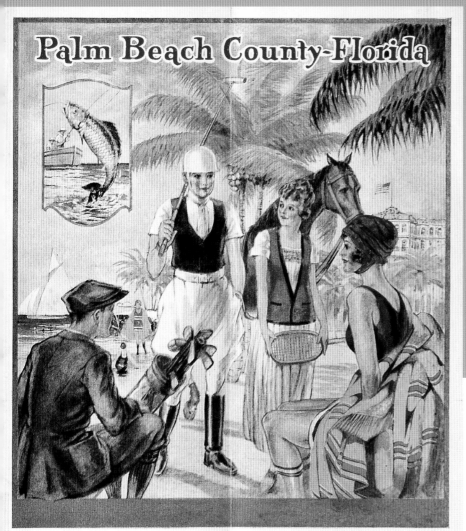

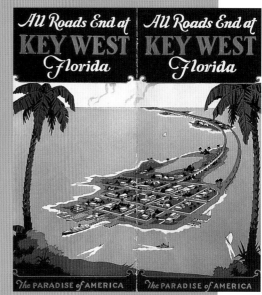

▲

PALM BEACH COUNTY, FLORIDA, c. 1925

"Because of the breezes from the Gulf Stream there rarely is any noticeable humidity in Palm Beach County. The absence of this undesirable exponent of heat explains why Florida can pride herself that her climate never has taken human life, and why heat prostration virtually is unknown in the State."

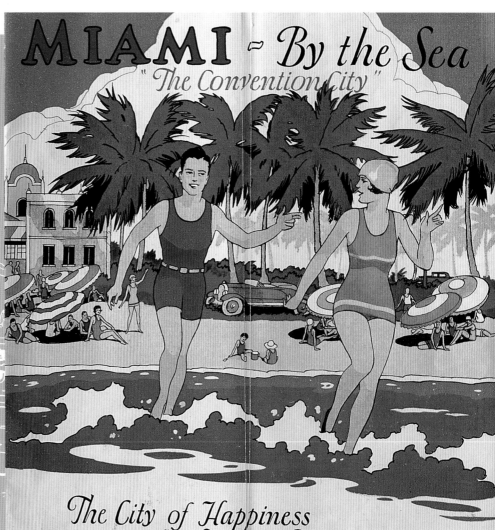

MIAMI ~ By the Sea
"The Convention City"

The City of Happiness
in the State of Florida

Revised Hotel, Apartment and Cottage Rates Guaranteed by the City of Miami

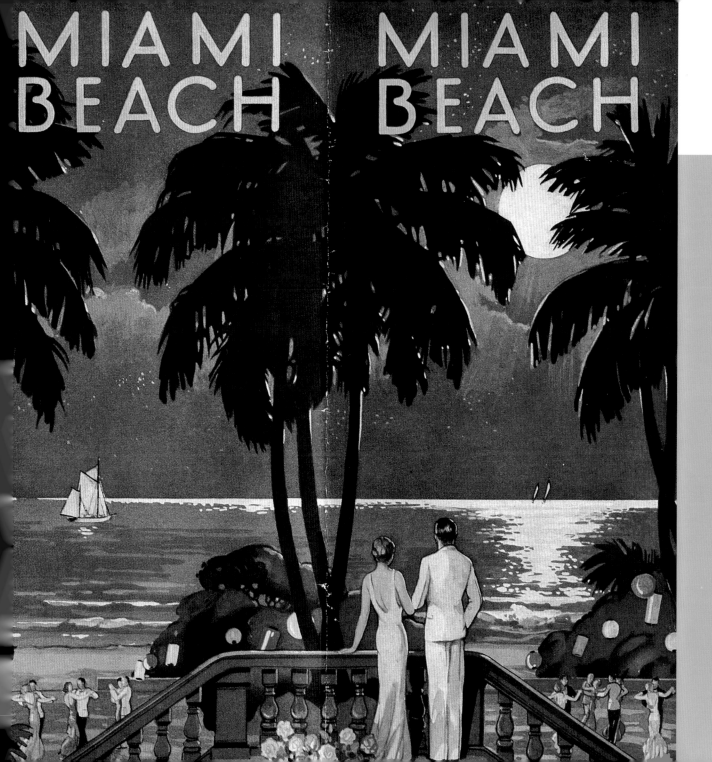

MIAMI BEACH

MIAMI BEACH

THIS IS MIAMI BEACH, 1940

"Here, within easy access by all modes of transportation, is an almost unbelievable translocation from slush, cold and dirt—to a modernized Shangri La."

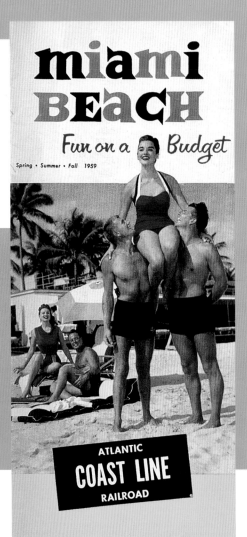

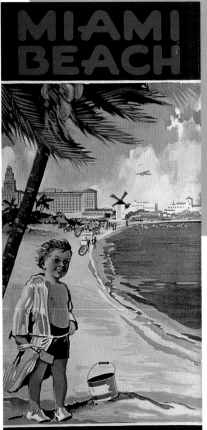

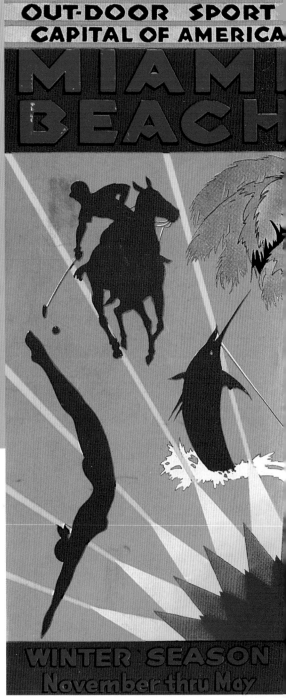

OUT-DOOR SPORTS CAPITAL OF AMERICA
MIAMI FLORIDA

WINTER SEASON
November thru May

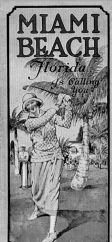
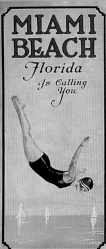
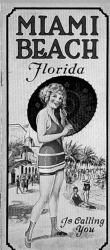
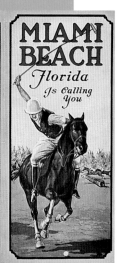

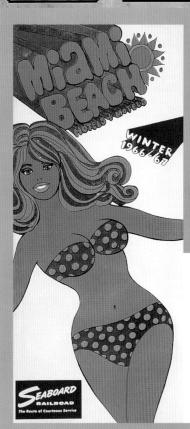

MIAMI-BY-THE-SEA, 1928

"Miami is the most gorgeous example of upper-class civilization on the planet."

William Allen White, Emporia (Kansas) *Gazette*

Gulf Coast

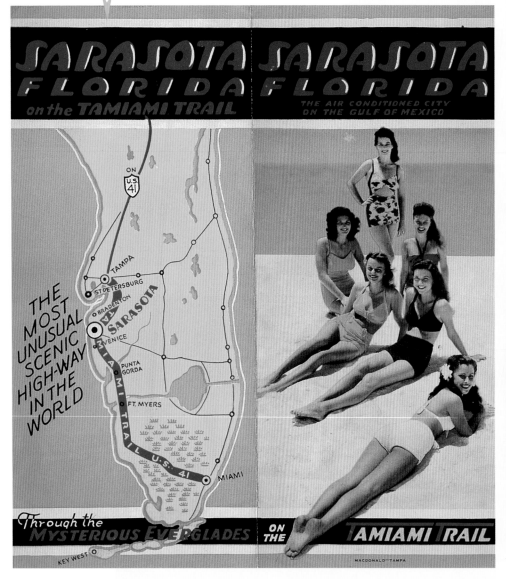

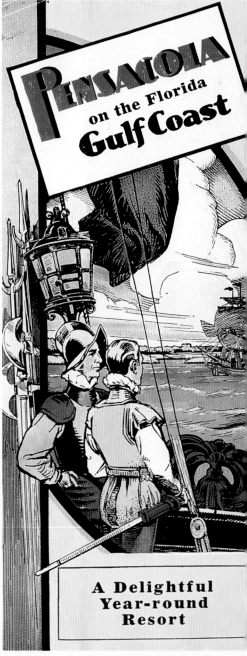

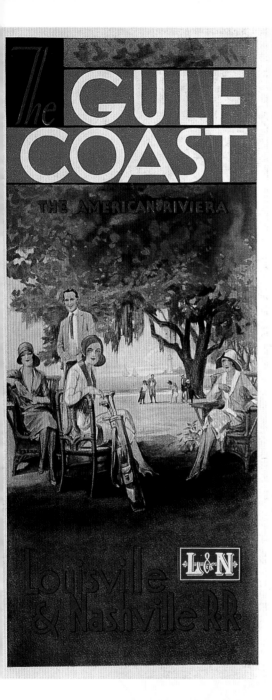

◄

THE GULF COAST: THE AMERICAN RIVIERA, 1930

"Summer has learned the business of being summer on the Gulf Coast.
She mocks at calendars and goes smiling through the year from June to
June, trailing her roses, magnolias, and oleander blooms, her sunlight
and soft winds . . .

"It is always summertime on the Gulf Coast, but it is summer with a tang
in it—the spice of pine trees and savor of salt-air. The sunlight that turns
the dancing waters into liquid sapphires and the white shell roads into
ribbons of silver is latticed and mellowed by pines and bearded live oaks."

Come to GALVESTON

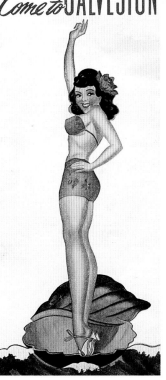

CORPUS CHRISTI

CORPUS CHRISTI

PORT of PLAY and PROFIT

PORT of PLAY and PROFIT

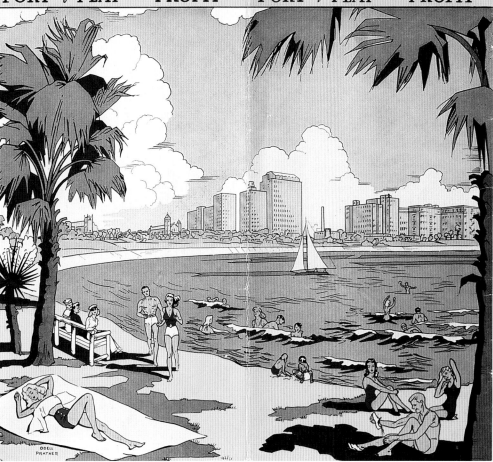
ODELL PRATHER

Pacific Coast

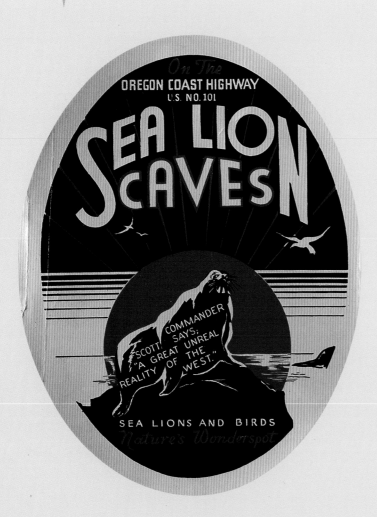

On The
OREGON COAST HIGHWAY
U.S. NO. 101
SEA LION CAVES

SCOTT, COMMANDER SAYS;
"A GREAT UNREAL REALITY OF THE WEST."

SEA LIONS AND BIRDS
Nature's Wonderspot

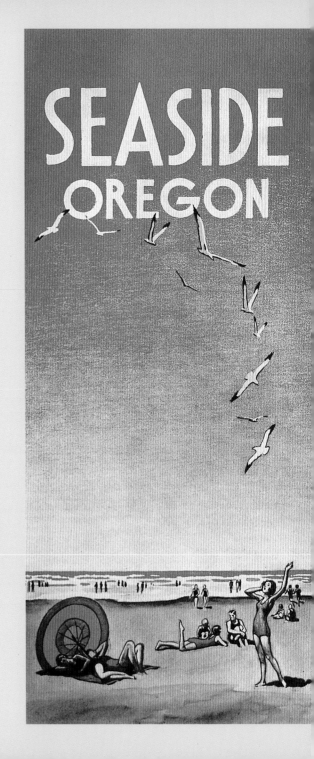

SEASIDE
OREGON

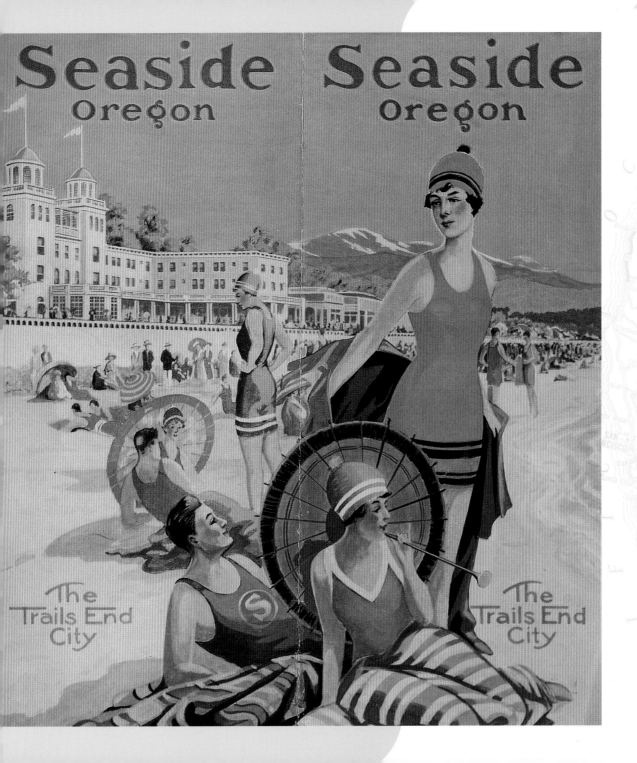

Seaside
Oregon

Seaside
Oregon

The Trails End City

The Trails End City

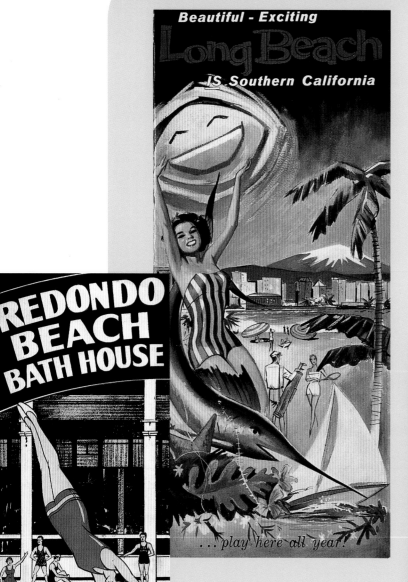

REDONDO BEACH BATH HOUSE

Open Every Day in the Year

Beautiful - Exciting
Long Beach
IS Southern California

...play here all year!

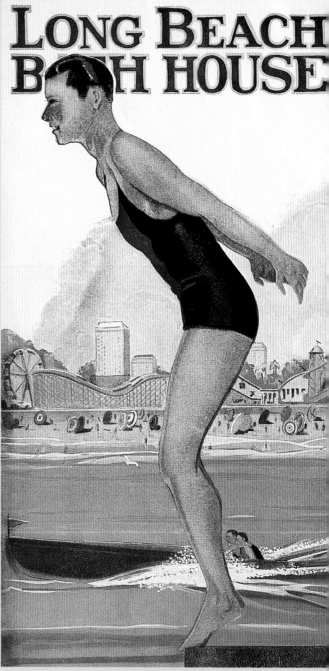

LONG BEACH BATH HOUSE

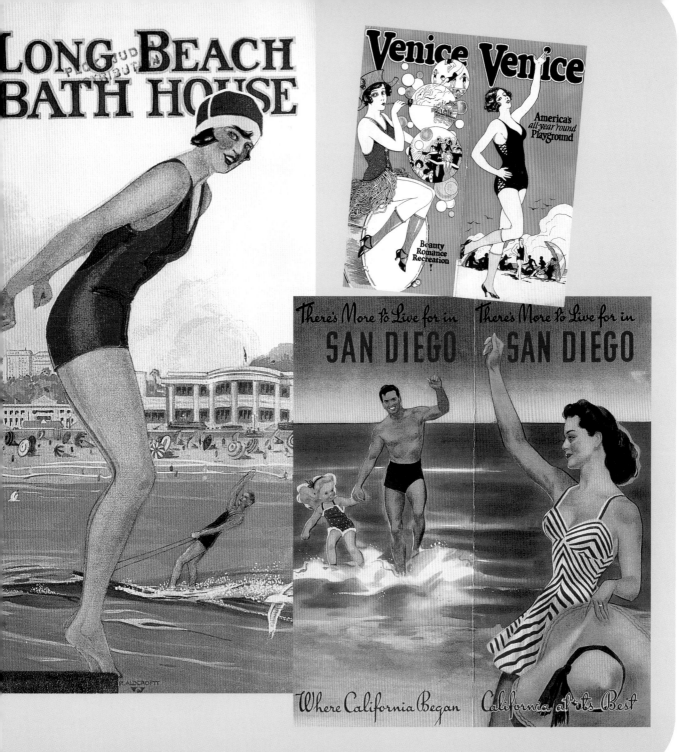

ENJOY THE TRIP TO SEAL ROCKS ▶
IN CATALINA, c. 1950

"If you are a seal, it means a lot to belong to
the right family. One variety lives in the ice
strewn Arctic waters and ends up as a fur
coat. But a luckier variety is protected by law
from being killed by hunters, lives happily to
a ripe old age of 35 or older, spends part of
every year in sunny Catalina! Often one wins
a career in show business!"

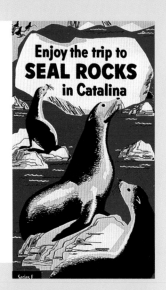

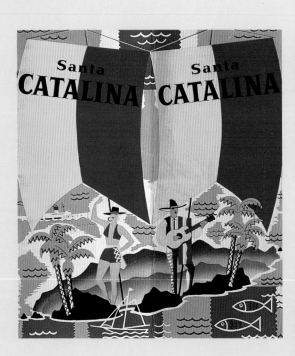

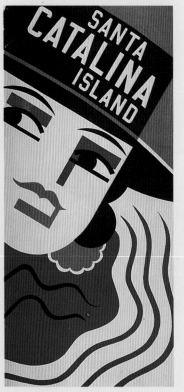

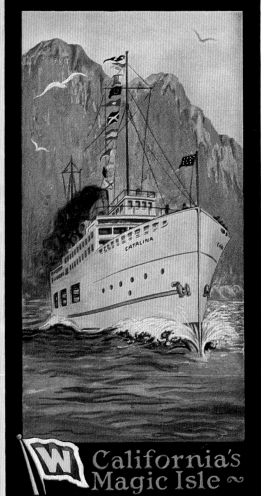

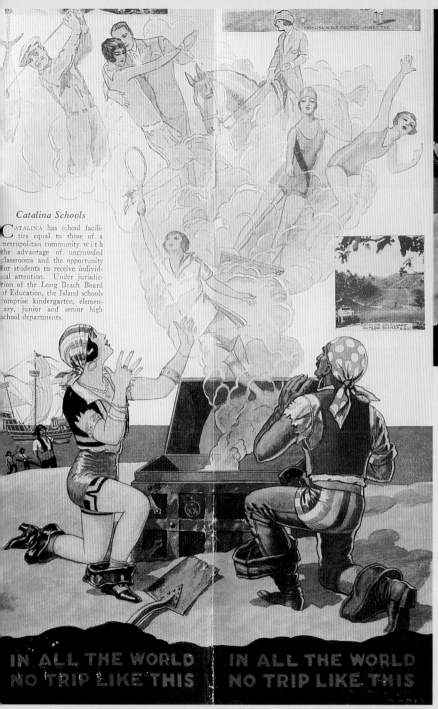

Catalina Schools

CATALINA has school facilities equal to those of a metropolitan community with the advantage of uncrowded classrooms and the opportunity for students to receive individual attention. Under jurisdiction of the Long Beach Board of Education, the Island schools comprise kindergarten, elementary, junior and senior high school departments.

CATALINA GOLF COURSE—FIRST TEE

CATALINA GOLF LINKS—SUPERB SCENERY

IN ALL THE WORLD
NO TRIP LIKE THIS

IN ALL THE WORLD
NO TRIP LIKE THIS

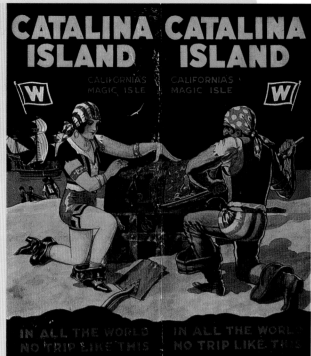

CATALINA ISLAND CATALINA ISLAND

CALIFORNIA'S MAGIC ISLE

CALIFORNIA'S MAGIC ISLE

W

W

IN ALL THE WORLD
NO TRIP LIKE THIS

IN ALL THE WORLD
NO TRIP LIKE THIS

NATURAL ATTRACTIONS

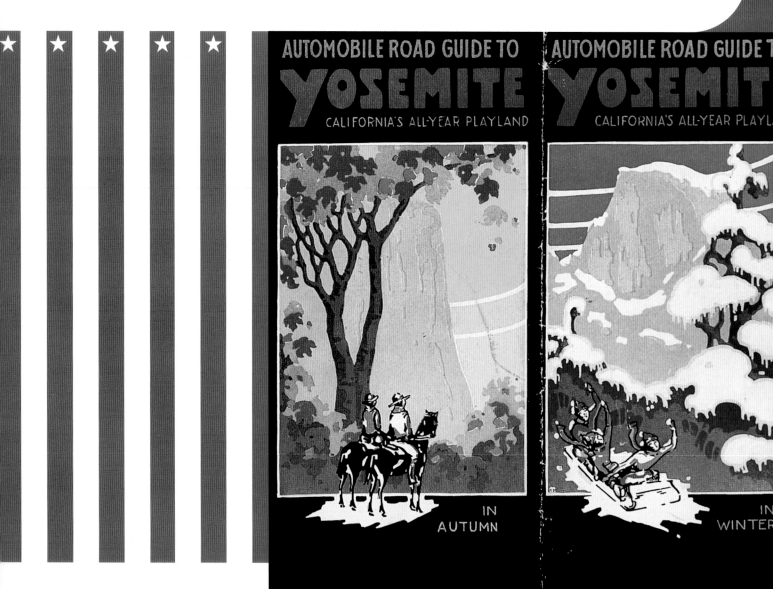

AUTOMOBILE ROAD GUIDE TO
YOSEMITE
CALIFORNIA'S ALL-YEAR PLAYLAND

IN
AUTUMN

AUTOMOBILE ROAD GUIDE TO
YOSEMITE
CALIFORNIA'S ALL-YEAR PLAYLA

IN
WINTER

IN
SPRING

IN
SUMMER

◀

YOSEMITE VALLEY, 1926

"The Sierra Nevada: Snowy Range has been well renamed by John Muir the Range of Light or these mountains of California are the Illumined Mountains. Their mural walls rise to over thirteen thousand feet, and the battlemented peaks and domes fifteen hundred feet higher in the clouds. On their flanks and lower sides are the dark covers of the world's greatest coniferous forests above."

National Parks

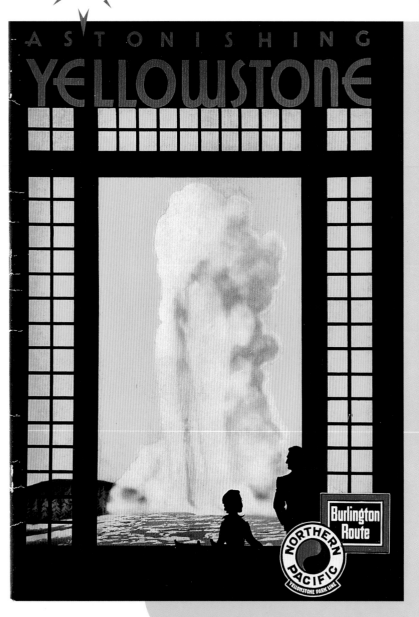

ASTONISHING
YELLOWSTONE

Burlington Route

NORTHERN PACIFIC
YELLOWSTONE PARK LINE

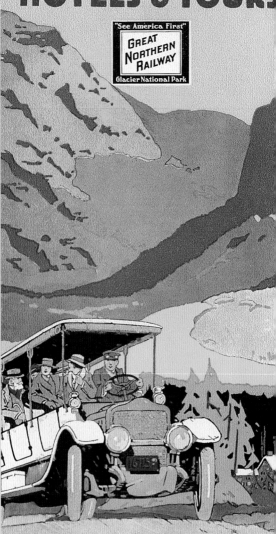

GLACIER
NATIONAL
PARK
HOTELS & TOURS

"See America First"
GREAT
NORTHERN
RAILWAY
Glacier National Park

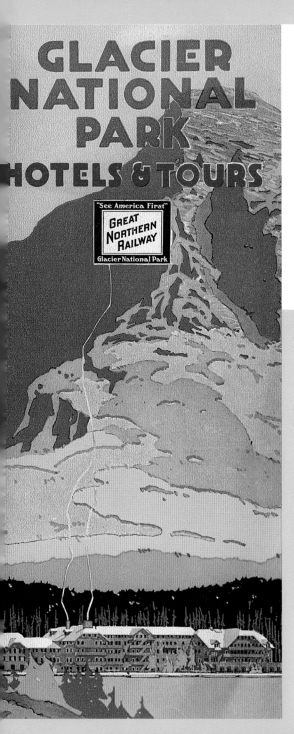

GLACIER
NATIONAL
PARK
HOTELS & TOURS

"See America First"
GREAT
NORTHERN
RAILWAY
Glacier National Park

YELLOWSTONE NATIONAL PARK, 1942

"Of all the national parks Yellowstone is the wildest and most universal in its appeal. There is more to see there—more different sorts of things, more natural wonders, more strange and curious things, more scope, more variety—a longer list of astonishing sights—than any half dozen of the other parks combined could offer. Daily new, always strange, ever full of change, it is the circus park. Nature's continuous Coney Island. It is the most human and the most popular of all the parks."

Emerson Hough, author of *The Covered Wagon*

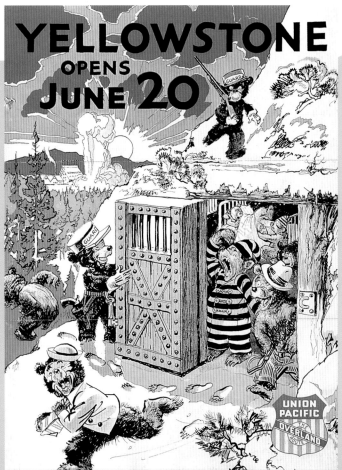

YELLOWSTONE
OPENS
JUNE 20

UNION
PACIFIC
THE
OVERLAND
ROUTE

97

Crater Lake

NATIONAL PARK

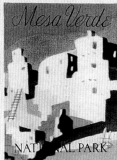

Mesa Verde

NATIONAL PARK

Arcadia

NATIONAL PARK

Death Valley

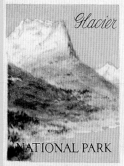

Glacier

NATIONAL PARK

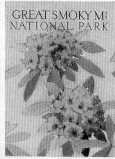

Carlsbad Caverns National Park

Platt National Park

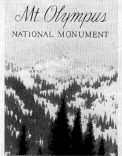

Mt. Olympus

NATIONAL MONUMENT

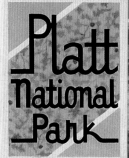

GREAT SMOKY M℥
NATIONAL PARK

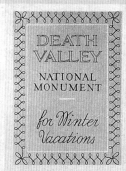

DEATH VALLEY

NATIONAL MONUMENT

for Winter Vacations

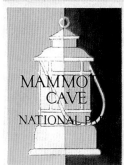

MAMMOTH CAVE

NATIONAL P℥

the Colorful Southwest

PETRIFIED FORESTS
NATURAL BRIDGES
CLIFF DWELLINGS
EARLY MISSIONS
INDIANS OF TODAY

in your National Monuments

GRAND TETON
NATIONAL PARK

Death Valley

6-37

Sam Hyde
HARRIS
L. A.

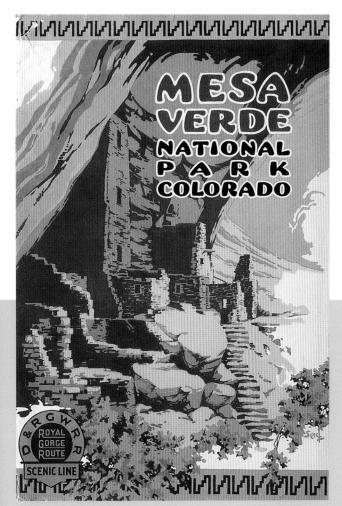

MESA VERDE NATIONAL PARK COLORADO

D&RGWRR
ROYAL GORGE ROUTE
SCENIC LINE

Wind Cave
NATIONAL PARK

Custer
STATE PARK

the Badlands
SOUTH DAKOTA

Zion
NATIONAL PARK

Yellowstone
NATIONAL PARK

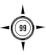

99

CRATER LAKE

CRATER LAKE

Crater Lake Nat'l. Park Co. ~ Southern Pacific

GRAND CANYON BOULDER DAM TOURS INC.

BY AIR
BY WATER
BY LAND

BRYCE CANYON
NATIONAL PARK

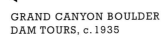

Lassen Volcanic
NATIONAL PARK

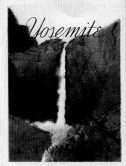

Yosemite
NATIONAL PARK

◀

**GRAND CANYON BOULDER
DAM TOURS, c. 1935**

"Author and painter alike have tried to
describe the beauty and magnitude of this
wonderland and all have admitted defeat.
The breath-taking panoramas, magnificent
coloring and awe-inspiring vastness, are
beyond the power of description."

State Parks

*Sequoia and
Kings Canyon*
NATIONAL
PARKS

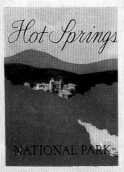

Hot Springs
NATIONAL PARK

SHENANDOAH
NATIONAL PARK

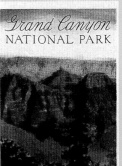

Grand Canyon
NATIONAL PARK

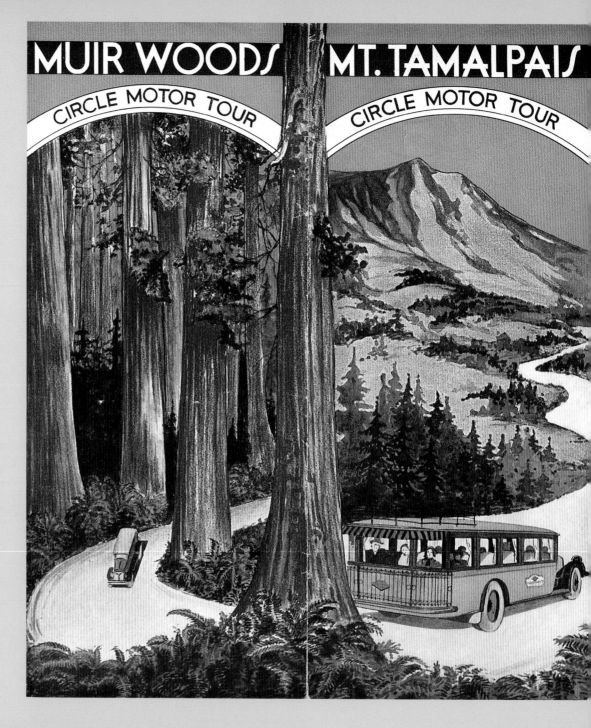

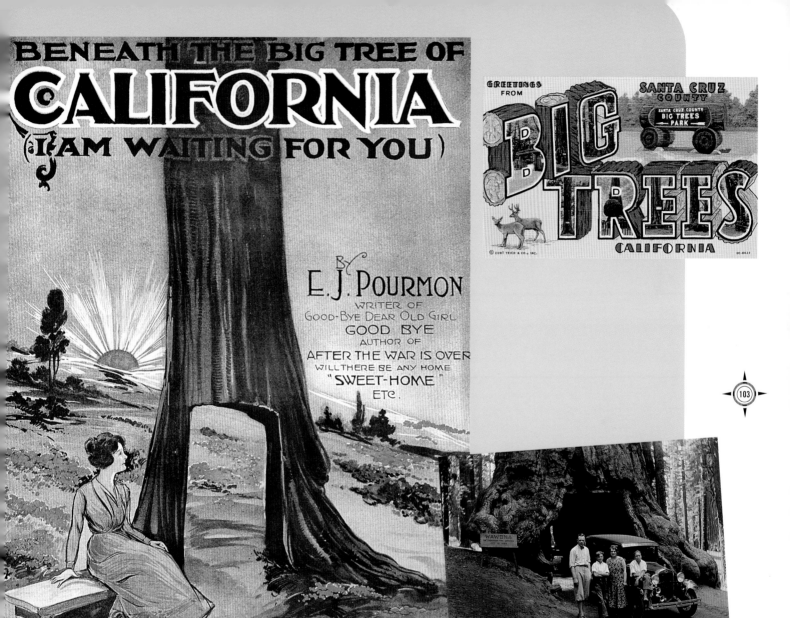

Mountains

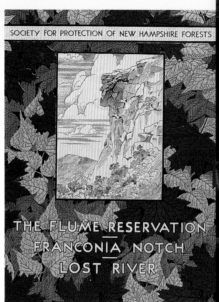

SOCIETY FOR PROTECTION OF NEW HAMPSHIRE FORESTS

THE FLUME RESERVATION
FRANCONIA NOTCH
LOST RIVER

THE FLUME RESERVATION, ▶
FRANCONIA NOTCH, 1938

"The wonderful chasm that exists along the flank of Mount Liberty for nearly seven hundred feet was discovered in 1808 by 'Aunt Jess' Guernsey then 93 years old. Although it is said that she was somewhat afflicted with senile dementia, her mind running to fishing, Mrs. Guernsey realized the value of her find."

AMONG THE ADIRONDACKS, c. 1900

"The Adirondacks or great forest of New York has long been famous as a hunting and fishing ground for the sportsman and one of the most marvelous natural sanitariums, where the tired and overworked, the convalescent and even invalids who have abandoned hope of recovery regain with wonderful rapidity their lost strength through the extraordinary tonic properties of the balsam-laden air."

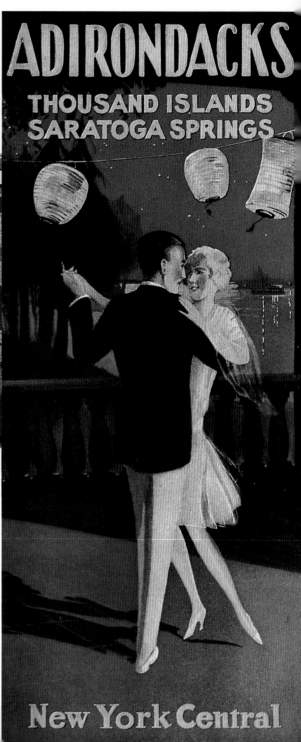

ADIRONDACKS
THOUSAND ISLANDS
SARATOGA SPRINGS

New York Central

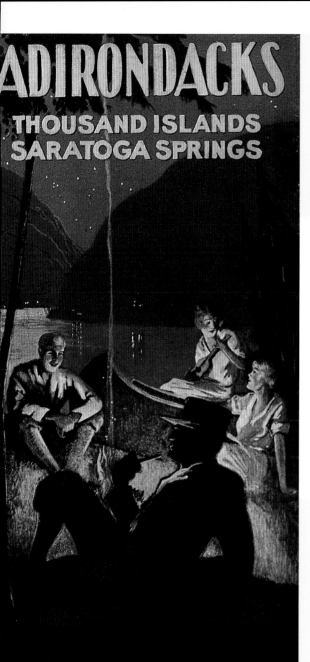

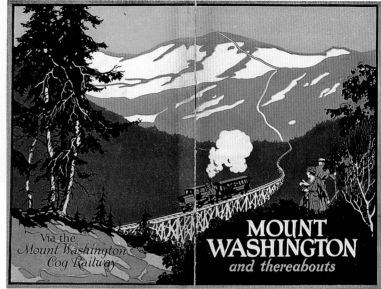

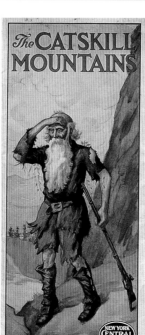

▲

**THE ROAD TO THE CLOUDS,
MOUNT WASHINGTON, c. 1955**

"This is the second greatest show on earth."

P. T. Barnum

(about the view from atop Mount Washington)

THE OZARKS, "THE LAND OF ▶ A MILLION SMILES," c. 1925

"One cannot analyze the perfume of a wild rose, nor may one explain wholly the lure of the Ozarks. After you have fished its streams, floated in a canoe through the blue magic of its moonlight, cantered over its trails in the freshness of early morning, and slept, night after night, beneath its stars, you will understand—a little. When, after many visits, you have come to know the land, then you will find that the charm of Ozarkland has stolen into your heart, holding you a delighted, healthy, happy, red blooded prisoner."

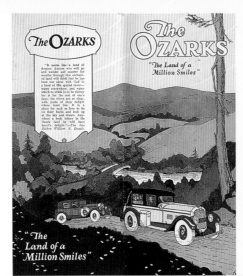

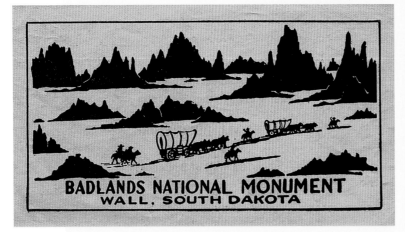

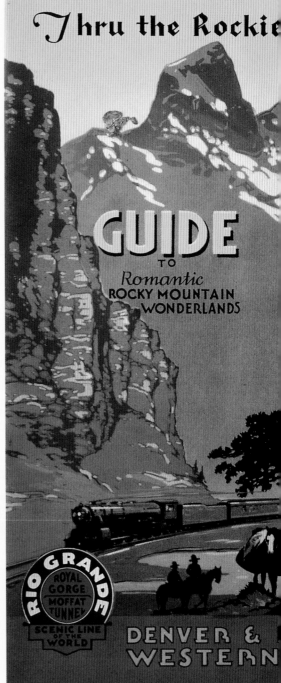

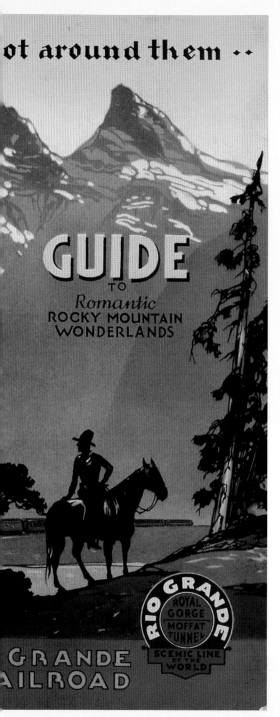

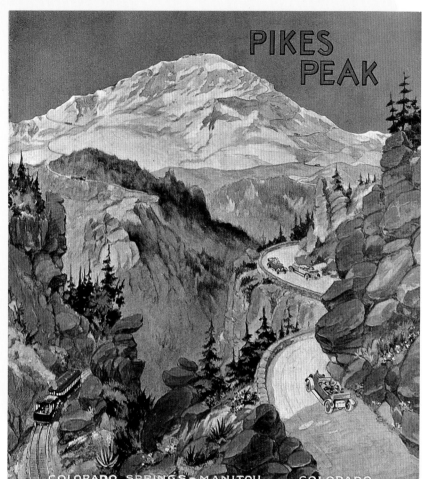

PIKES PEAK

COLORADO SPRINGS - MANITOU. COLORADO

SOUTH DAKOTA'S BLACK HILLS AND BIG BADLANDS, c. 1950

"An endless supernatural world more spiritual than Earth but created out of it . . .

the aspects of the South Dakota Badlands have more spiritual quality to impart to

the mind of America than anything else in it made by Man's God."

Frank Lloyd Wright

Lakes and Rivers

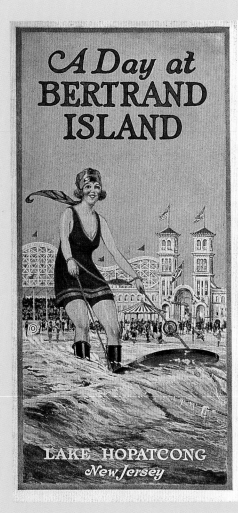

A Day at BERTRAND ISLAND

LAKE HOPATCONG
New Jersey

LAKE TAHOE, FOR RECREATION ▶
HEALTH AND REST, c. 1920

"At last the lake burst upon us—a noble sheet of blue water lifted six thousand three hundred feet above the level of the sea, and walled in by a brim of snow-clad peaks that towered aloft full three thousand feet higher still. . . . I thought it must surely be the fairest picture the whole earth affords."

Mark Twain

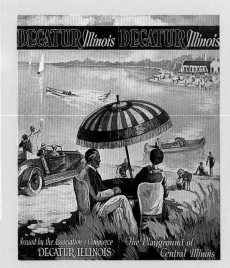

DECATUR *Illinois* DECATUR *Illinois*

Issued by the Association of Commerce
DECATUR, ILLINOIS

The Playground of Central Illinois

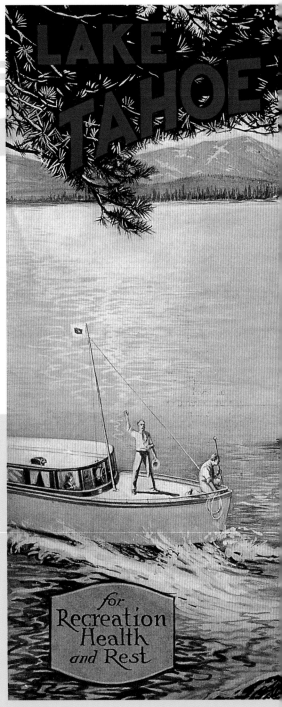

LAKE TAHOE

for Recreation Health *and* Rest

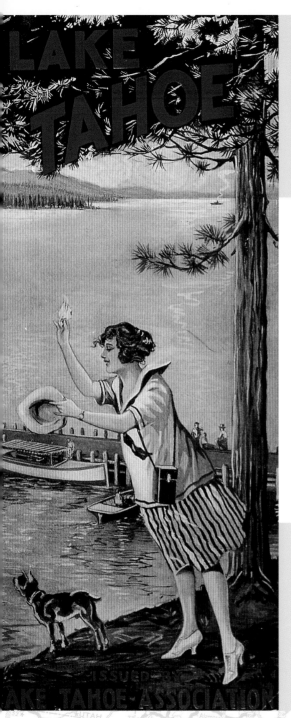

LAKE
TAHOE

ISSUED BY
LAKE TAHOE ASSOCIATION

Lake
Chelan
CASCADE MOUNTAINS

Lake
Chelan
CASCADE MOUNTAINS

GREAT NORTHERN RAILWAY
SEE AMERICA FIRST

GREAT NORTHERN RAILWAY
SEE AMERICA FIRST

IMMORTAL NIAGARA OFFICIAL GUIDE BOOK, 1950

"It was not until I came on Table Rock and looked, great Heaven! On what a fall of bright green water—that it came upon me in its full majesty. Then I felt how near to my Creator I was standing; the first effect and the enduring one, instant and lasting, of the tremendous spectacle was peace. Peace of mind, tranquillity, calm recollections of the dead, great thoughts of the Eternal rest and happiness, nothing of gloom or terror. Niagara was at once stamped upon my heart an image of beauty, to remain there changeless and indelible until its pulses cease to beat forever."

Charles Dickens

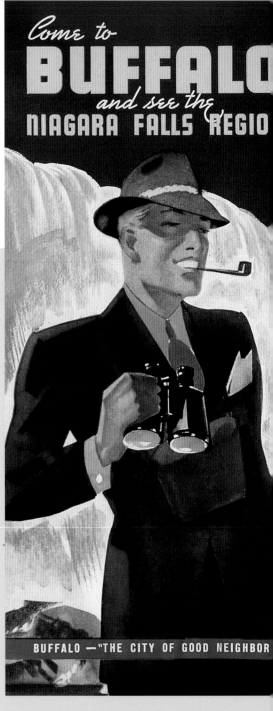

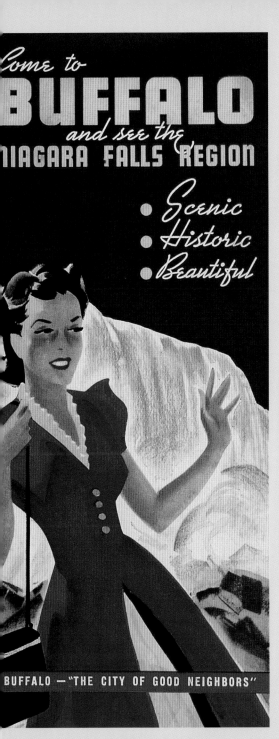

BUFFALO — "THE CITY OF GOOD NEIGHBORS"

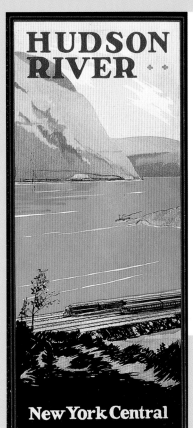

New York Central

HUDSON RIVER, 1926

"What a wonderful river! I have never realized that there was such scenery here, and that the approach to the great City of New York was so beautiful. The Palisades, those great walls of rock, are most impressive as are also the Highlands. It seems to me that you do not say enough about the beauties of this region otherwise all the world would be coming to see it."

Viscount Haldane
former Lord High Chancellor of England

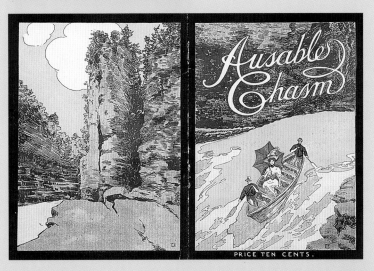

PRICE TEN CENTS.

Caves

ENDLESS CAVERNS: 1929

"Two and one-half miles of underground halls, studded with glittering formations, revealed by marvelous electric lighting. End not yet found."

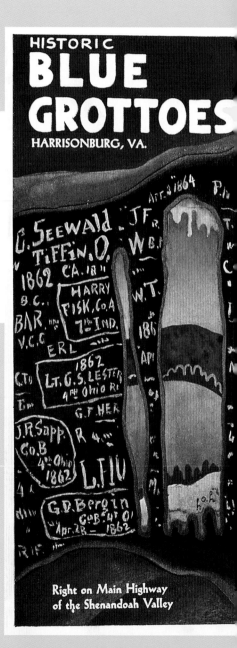

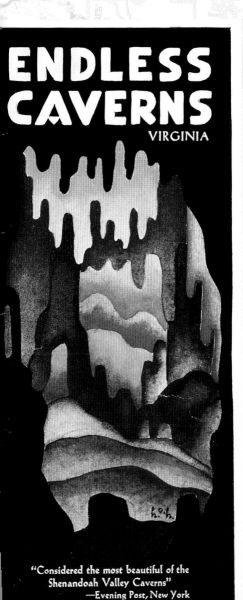

ENDLESS CAVERNS
VIRGINIA

"Considered the most beautiful of the Shenandoah Valley Caverns"
—Evening Post, New York

CYCLOPEAN TOWERS
MT. SOLON VIRGINIA

Great Sentinels in Stone

SAPPHIRE POOL
VIRGINIA
in the Shenandoah Valley

Unfathomed Depths
Electrically Illuminated

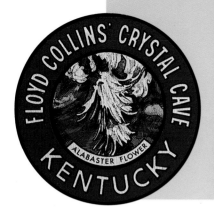

FLOYD COLLINS CRYSTAL CAVE
IN KENTUCKY, c.1940

"[Floyd Collins] soon brought to the attention of the outside world what is today thought of as The First Lady of Caveland, the Floyd Collins Crystal Cave. From that moment until his untimely death in 1925. While trying to locate a new entrance to it by the highway at Sand Cave, this inveterate cave man concentrated his efforts and energy toward developing his prize. That he should lose his life in an effort to make his cave accessible to the public was unfortunate."

BULL SHOALS CAVERNS

APPROVED

BULL SHOALS, ARKANSAS

12 BLOCKS FROM BULL SHOALS DAM

Carlsbad Caverns NATIONAL PARK

GENERAL INFORMATION for the GUIDANCE OF THE VISITOR

PUBLISHED and DISTRIBUTED By
CAVERN SUPPLY Co
CARLSBAD · NEW MEXICO

BAKER CAVERNS
PENNSYLVANIA, c. 1935

"There are many formations which bear resemblance to things of the outer world. Canopies, tents, the head of an elephant with circus trappings, mammoth turtle, faces, the huge jaw of an alligator, shields, leather hangings with fringes, water falls, animals, etc., all can be seen in the shapes which the cave onyx took."

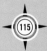

SCENE IN WONDERLAND NIGHT CLUB, WONDER CAVE

ACCOMMODATES 2500 PEOPLE—BELLA VISTA, ARKANSAS 1832-30

DINOSAUR HUNTING LICENSE
SPECIAL PERMIT
No. I 81—U022

ISSUED TO:	
Name	KURT KJELLIN
Street	331 EAST 23RD ST.
City	NEW YORK 10 State NEW YORK

ISSUED BY AUTHORITY U. S. REPTILE CONTROL COMMISSION

Restricted to Uintah County, Utah, Only

This license entitles the holder to hunt for, pursue, shoot, kill and remove from that area known as Dinosaur Control Area of Uintah County, Utah, which is in the vicinity of Dinosaur National Monument the following types of reptilian wild game:

A. TYRANNOSAURUS REX — 1 only (Adult Male)

B. DIPLODOCUS GIGANTICUS — 1 only (Either Sex) and not less than 5000 lbs. live weight

C. STEGOSAURS — 2 only (Males) any size

D. PTERODACTYLI — 4 only (without young)

The holder of this license agrees to remove all such game, legally bagged by him under the proper restrictions, properly preserved and in sanitary condition within 5 days of time of reptiles' death, and further agrees to have said game inspected by the Utah Game Warden before removal.

Signed _Al E. "Tony Wirtz" Oup_

ISSUED BY AL E. OUP
Deputy Lizard Warden, Vernal, Utah

◄

NATURAL BRIDGE
OF VIRGINIA, 1929

"The only practical world wonder."
Will Rogers

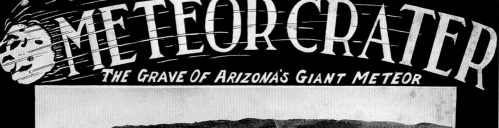

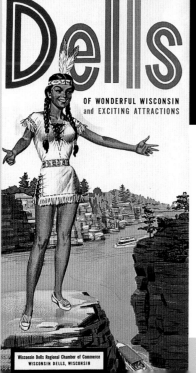

LOWER DELLS, c. 1935

"These sights . . . are to be found nowhere else. The Gigantic Arrowhead, a Football of solid rock weighing countless tons, the Huge Hawk's Bill, the Baby Grand Piano, the Cave of Dark Waters, a giant replica of a Milk Bottle cut out of solid stone over 80 feet high, the Great Inkstand, the Memorable Sugar Bowl, and other points of interest will be found in the Lower Dells."

ON VACATION

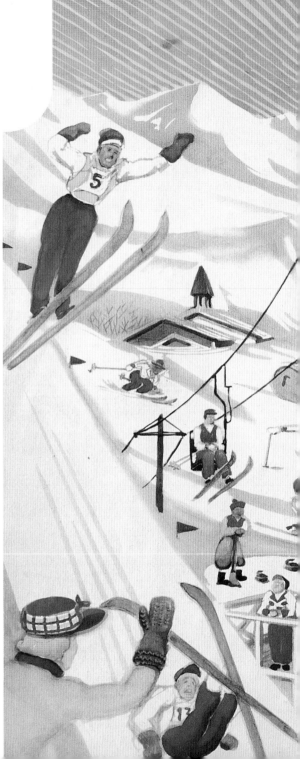

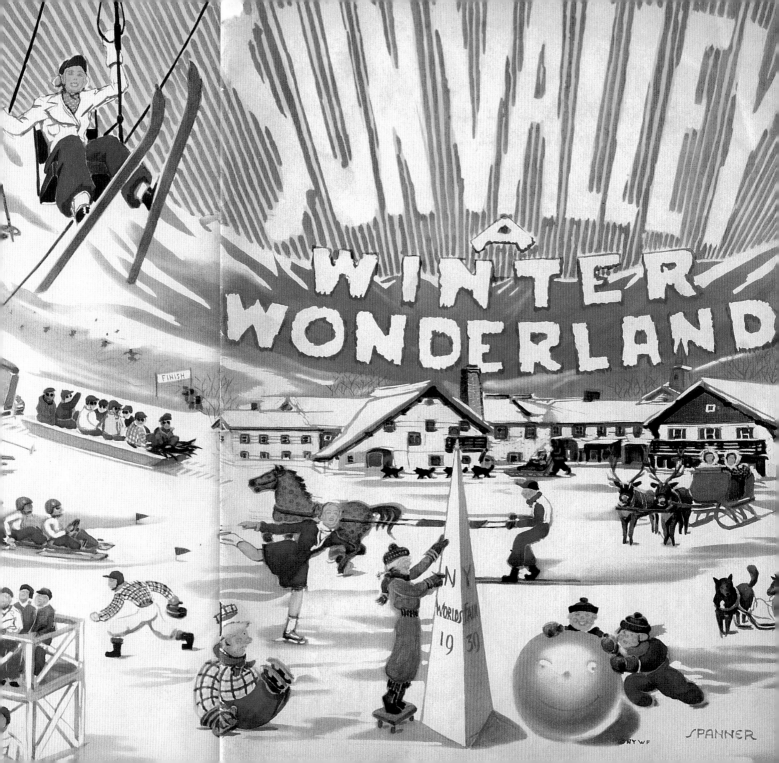

Fun, Fun, Fun

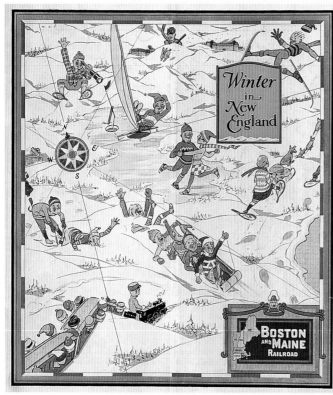

Winter in New England

BOSTON AND MAINE RAILROAD

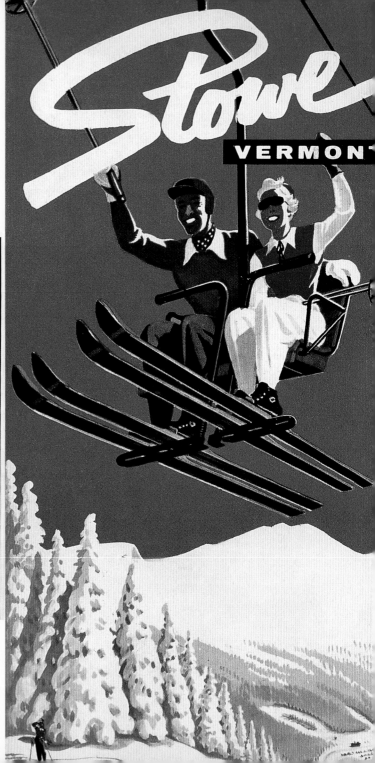

Stowe
VERMONT

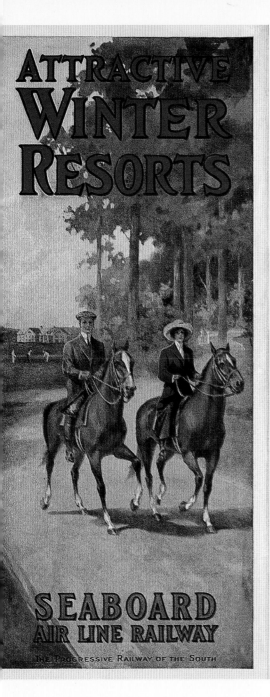

ATTRACTIVE WINTER RESORTS

SEABOARD AIR LINE RAILWAY

The Progressive Railway of the South

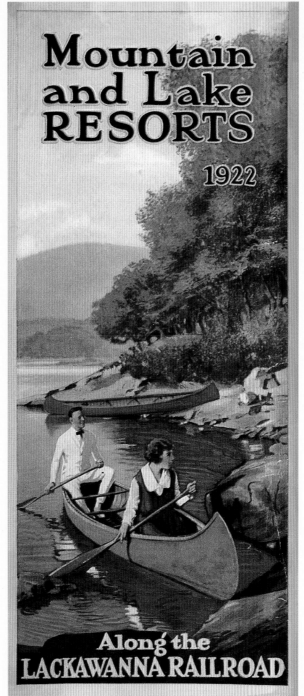

Mountain and Lake RESORTS

1922

Along the LACKAWANNA RAILROAD

LAKE GEORGE

"The D&H"

Golfing

Spokane

Heart of the Pacific Northwest,

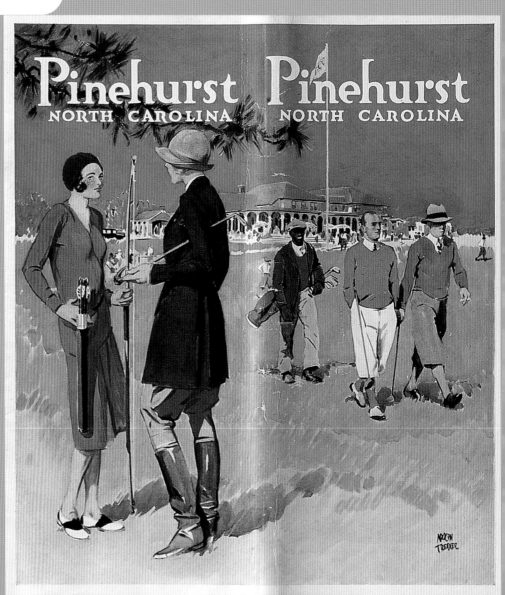

Pinehurst
NORTH CAROLINA

Pinehurst
NORTH CAROLINA

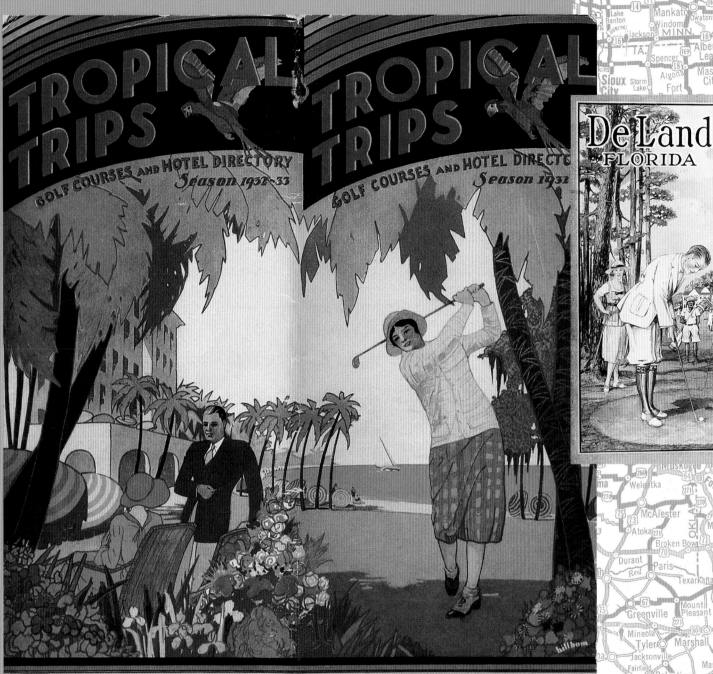

Warren County Warren County

NEW YORK STATE

A Vacation Paradise In The Adirondack Mountains

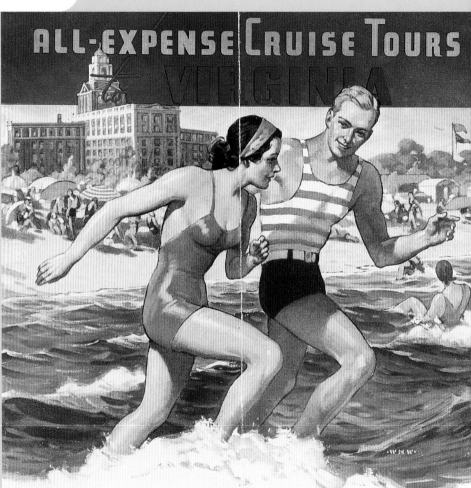

ALL-EXPENSE CRUISE TOURS
VIRGINIA

OLD DOMINION LINE
OF EASTERN STEAMSHIP LINES

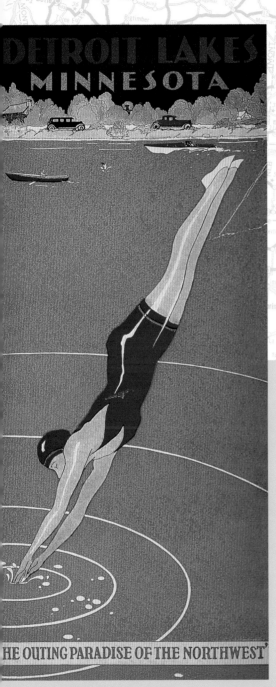

DETROIT LAKES
MINNESOTA

THE OUTING PARADISE OF THE NORTHWEST

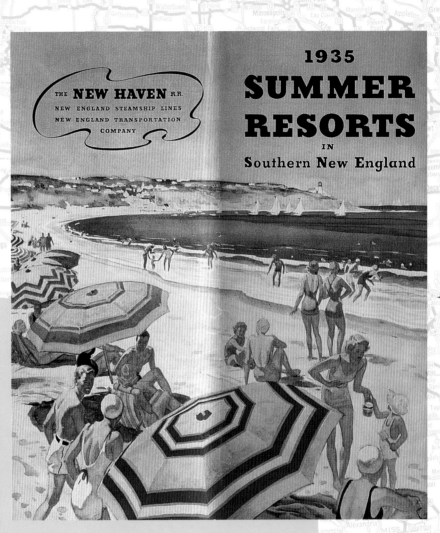

THE **NEW HAVEN** R.R.
NEW ENGLAND STEAMSHIP LINES
NEW ENGLAND TRANSPORTATION
COMPANY

1935
SUMMER
RESORTS
IN
Southern New England

Fishing

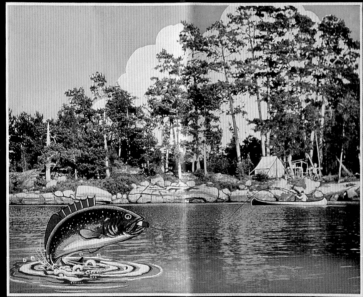

WISH YOU WERE HERE . . . MINNESOTA'S
MARVELOUS, c. 1955

"Stories about the big ones that didn't get away make news

in Minnesota."

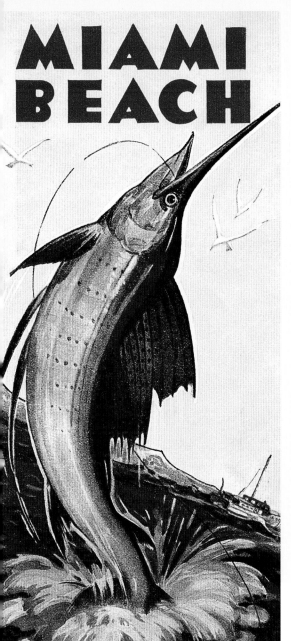

MIAMI BEACH

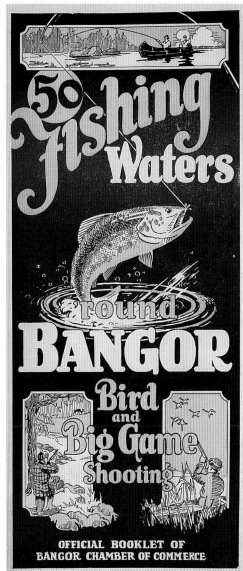

50 Fishing Waters 'round BANGOR Bird and Big Game Shooting

OFFICIAL BOOKLET OF
BANGOR CHAMBER OF COMMERCE

CAPE VINCENT NEW YORK
The Home of the Gamy BLACK BASS

FLORIDA FISHING, 1919

"All stories of Florida fishing, from tarpon fishing down to smaller achievements, read like works of fiction, and visiting fishermen from distant points are very apt to doubt the truth of most of them."

ACKNOWLEDGMENTS

Those organizations and individuals who helped to sponsor and underwrite the cost of the research: The Architectural League of New York; Joanne Cassullo; Rosalie Genevro; the John Simon Guggenheim Memorial Foundation; Ellen Harris; Barbara Jakobson; Philip Johnson; the Dorothea L. Leonhardt Foundation; the National Endowment for the Arts in Washington, D.C., a federal agency; Susan Plum; and Bagley and Virginia Wright.

Those people who helped to produce the book: Jeff Berg, David Blankenship, and Joan Welsch at Eric Baker Design Associates; photographer Becket Logan; editorial coordinator Terry Hackford; researchers Margot Norton and Mark Herdter; and our editors at Chronicle Books, Bill LeBlond and Alan Rapp.

Those people who shared their expertise and collections: Jim Akerman at the Herman Dunlap Smith Center for the History of Cartography at the Newberry Library, Chicago; Sam Boldrick at the Miami-Dade Public Library; DeSoto Brown; Joanne Cassullo; John and Jean Dunning; David Farmer and Betty Friedrich at the Degolyer Library, Southern Methodist University; Blake Fleetwood; Ira Galtman and Nancy Muller at American Express; Amy Golin at the Wolfsonian-Florida International University, Miami Beach; Lee Harrison; Alice Hudson at the New York Public Library; Jimmy Hutzler, John Ingram, and Joyce Dewsbury at the George Smathers Library at the University of Florida; Jim Masson; Georgia Orcutt; Karen Shatzkin; and Kathy Triebel at the Phillips 66 Archive.

BIBLIOGRAPHY

Baker, Eric, and Tyler Blik. *Trademarks of the 20's and 30's.* Chronicle Books, San Francisco, 1986.

—. *Trademarks of the 40's and 50's.* Chronicle Books, San Francisco, 1988.

Baker, Eric, and Jane Martin. *Great Inventions, Good Intentions: An Illustrated History of Design Patents.* Chronicle Books, San Francisco, 1990.

Boorstin, Daniel J. "From Traveler to Tourist: The Lost Art of Travel." Chapt. 3 in *The Image: Or, What Happened to the American Dream.* Atheneum Publishers, New York, 1961.

Braden, Donna R., and Judith E. Endelman. "Americans on Vacation." Exhibition catalog. Henry Ford Museum & Greenfield Village, Dearborn, Michigan, 1990.

Brown, DeSoto. *Aloha Waikiki: 100 Years of Pictures From Hawaii's Most Famous Beach.* An Editions Limited Book, Honolulu, 1985.

—. *Hawaii Recalls: Selling Romance to America; Nostalgic Images of the Hawaiian Islands: 1910–1950.* An Editions Limited Book, Honolulu, 1982.

Dunbar, Seymour. *A History of Travel in America.* Tudor Publishing Company, New York, 1937.

Dyer, Rod, and Brad Benedict, text by David Lees. *Coast to Coast: The Best of Travel Decal Art.* Abbeville Press, New York, 1991.

Friedheim, Eric. *Travel Agents: From Caravans and Clippers to the Concorde.* Travel Agent Magazine Books, Universal Media, New York, 1992.

Guide to the Western Ephemera Collection. DeGolyer Library, Southern Methodist University, Dallas, 1993.

Hill, Cissie Dore, and Katherine Church Holland (co-curators). "Sunset Magazine: A Century of Western Living, 1898–1998." Exhibition catalog. California Historical Society, Hoover Institution, Stanford University and Stanford University Libraries, Palo Alto, California, 1998.

Jakle, John A. *The Tourist: Travel in Twentieth-Century North America.* University of Nebraska Press, Lincoln, Nebraska, 1985.

LaHurd, Jeff. *Come On Down: Pitching Paradise During the Roaring '20s.* Sarasota Alliance for Historic Preservation, Sarasota, Florida, 1995.

Margolies, John. *The End of the Road: Vanishing Highway Architecture in America.* Penguin Books, in collaboration with the Hudson River Museum, Yonkers, New York, 1977, 1978, 1981.

—. *Fun Along the Road: American Roadside Attractions.* Bulfinch Press/Little, Brown & Company, Boston, 1998.

—. *Home Away From Home: Motels in America.* Bulfinch Press/Little, Brown & Company, Boston, 1995.

—. *Pump and Circumstance: Glory Days of the Gas Station.* Bulfinch Press/Little, Brown & Company, Boston, 1993.

Margolies, John, Nina Garfinkel, and Maria Reidelbach. *Miniature Golf.* Abbeville Press, New York, 1987.

Margolies, John, and Emily Gwathmey. *Signs of Our Time.* Abbeville Press, New York, 1993.

Schwantes, Carlos A. *Railroad Signatures Across the Pacific Northwest.* University of Washington Press, Seattle, 1993.

Steele, H. Thomas. *Lick 'Em, Stick 'Em: The Lost Art of Poster Stamps.* Abbeville Press, New York, 1989.

Sutton, Horace. *Travelers: The American Tourist from Stagecoach to Space Shuttle.* William Morrow and Company, New York, 1980.

Vinson, Michael. "Motoring Tourists and the Scenic West, 1903 to 1948." Exhibition catalog. DeGolyer Library, Southern Methodist University, Dallas, 1989.

Yorke, Douglas A., Jr., John Margolies, and Eric Baker. *Hitting the Road: The Art of the American Road Map.* Chronicle Books, San Francisco, 1996.

Periodicals

Brown, DeSoto. "Hawaii: Never Easier to Sell." Cultural Resource Management (National Park Service), Washington, D.C., V. 21, no.8 (1998): 28–30.

The Journal of Decorative and Propaganda Arts (The Wolfsonian-Florida International University), Miami Beach, 23, Florida theme issue (1998).

Lowen, Sara. "Adventures in Souvenirland." *Mid-Atlantic Country,* Greenbelt, Maryland. (October 1993): 36–41, 78–79.

Walther, Gary. "Niagara Souvenirs: One Man's Love Affair with Kitsch." Smithsonian, Washington, D.C., (January 1984): 106–111.

SOURCE LIST

Notes: Directional arrows throughout the book indicate that the excerpted text is drawn from the displayed brochure. Road map details from the cover and throughout the book are from a U.S. map included as part of a 1932 Phillips Petroleum Company road map of Missouri; map art work © by Gallup Map and Supply Co., Kansas City, Mo.; courtesy: Phillips Petroleum Company. In all cited brochure measurements the width precedes the height.

Inside covers
Stickers: Arizona, Yellowstone Park Cody Road, Texas Friendship State, and Carlsbad, New Mexico. Windshield decals: California (produced by Baxter Lane Co., Amarillo); Colorado (produced by Color-Ad Display Co., Denver); Flamingo Everglades National Park, Florida (produced by the Meyercord Co., Chicago); Georgia; Idaho; Massachusetts (produced by Fairway Mfg. Co., St. Louis); Pennsylvania Dutch Country; and Rhode Island (produced by Fairway Mfg. Co., St. Louis).

Page 1: *Uncle Sammy March—Two Step,* sheet music cover, 10¾ x 14", 1904. 2–3: *Paste-Up Map of the United States for Boys and Girls,* © 1949 by D. M. Latta, Carthage, Mo., distributed by State Bank of Atwood, Kans., 17 x 11"; selected poster stamps, ca. 1920–1940. 4: *Travel Guide, Summer-Winter,* Missouri Pacific Lines, 64-page booklet, 8½ x 11½", ca. 1925. 6: *See The U.S.A. Missouri Pacific Way,* issued by Missouri Pacific Lines, foldover brochure, 8 x 9", 1928.

Introduction
7: *Travel Trips,* issued by Simmons Tours, New York, N.Y., 88-page booklet, 6½ x 9½", Vol. 276, Summer Edition, 1929. 8: (from left) *Summer Vacation Trips,* issued by American Express Travel Department, 10-page booklet, 4 x 9", May, 1917, courtesy of American Express Corporate Archives; *Tropical Trips: Golf Courses and Hotel Directory,* back cover illustration, issued by Atlantic Coast Line Railroad, 32-page foldover brochure, 8 x 9", 1933–34; *Long Island: America's Sunrise Land,* issued by Long Island Railroad, foldover brochure, 6 x 9", ca. 1930. 9: *Tugby's Illustrated Guide to Niagara Falls,* photographic foldout viewbook, each panel 4½ x 5½" (folds out to a total length of 64") and 58 pp, 1885. 10: Die-cut foldout brochure issued by The Flume Reservation and Lost River Reservation, Franconia, N. H., 4 x 8½" (folds out to 16"), 1941. 11: (left) *Hawaii: A Primer/Being A Series of Answers to Queries,* Hawaii Promotion Committee, 48-page booklet, 1905, DeSoto Brown Collection; (right) *Florida Facts,* issued by The Bureau of Immigration, Department of Agriculture, State of Florida Tallahassee, 28-page booklet, 8½ x 9½", produced by Florida Growers Press, Tampa, Fla., 1928, Florida Ephemera Collection, Department of Special Collections, George A. Smathers Libraries, University of Florida, Gainesville. 12: *Alice's Adventures in the New Wonderland: The Yellowstone National Park,* issued by the Northern Pacific Railway, foldover brochure, each panel is

3¹/₂ x 8¹/₄" (folds out five panels wide and three panels high to a flat size of 24¹/₂ x 18¹/₂"), produced by Poole Bros. Printers, Engravers, Chicago, 1885, DeGolyer Library Collection, Southern Methodist University, Dallas. 13: *Cross the Mississippi at Cape Girardeau*, mileage chart in foldover brochure and road map, 9 x 8", ca. 1950. 15: *New Rochelle: The City of the Huguenots*, "The Commuter's Homecoming" illustration, © the New Rochelle Chamber of Commerce, 36-page booklet, 6¹/₂ x 10", printed by The Knickerbocker Press, New Rochelle, 1926.

Parade of the States

16–17: *This Amazing America: Strange and Unusual Places Reached by Greyhound Lines*, 24-page booklet, 8 x 9", 1936. 18: (left) Linen postcard produced by Colourpicture, Cambridge, Mass., 5¹/₂ x 3¹/₂", ca. 1940; (right) *Your New England Vacation: Where to Go . . . What It Will Cost*, issued by the Recreational Development Committee of the New England Council, Boston, cover drawing by John Held, Jr. for the New York, New Haven and Hartford Railroad, 25-page booklet, 6¹/₄ x 9¹/₂" with a foldout cover-map, 12¹/₄ x 18¹/₄", ca. 1925; (quotation) *New England Tours*, published by the New England Hotel Association, foldover brochure, 4 x 9" (folds out to 16 x 18"), 1918. 19: *Summer in New England*, issued by the Boston and Maine Railroad, 64-page booklet, 8 x 9", 1932. 20: (top) *New Hampshire*, published by the New Hampshire Hotel Association, Manchester, 16-page booklet printed by Lew A. Cummings Co., Manchester, ca. 1930; (bottom) *Maine Camping Canoeing*, © Maine Development Commission, foldout brochure, 8 x 9" (folds out to 16 x 18"), 1932; (quotation) *Concord New Hampshire: A Residential City of Commerce and Industry*, published by the Concord Chamber of Commerce, soft-cover 74-page booklet printed by The Rumford Press, Concord, 5 x 7³/₄", 1922. 21: (left) *Trolleying Around Portland, Maine*, published by the Portland Railroad Co., 16-page booklet produced by Printwell Printing Co., Portland, 8¹/₈ x 8¹/₈", ca. 1910; (quotation and upper right) *Unspoiled Vermont*, published by Development Commission, Montpelier, Vt., 16-page foldover brochure, 8 x 9", ca. 1950; (lower right) *Maine: The Land Of Remembered Vacations*, a re-issue of *Eastward Ho to Maine* and *Maine Extends a Cordial Welcome*, compiled by Harrie B. Coe, published by the Maine Development Commission, Augusta, 64-page booklet, 8 x 9", ca. 1930; (quotation and upper right) *Unspoiled Vermont*, published by Development Commission, Montpelier, 16-page foldover brochure, 8 x 9", ca. 1950. 22: (left) *This Is Pennsylvania*, published by State Department of Commerce, Harrisburg, 32-page booklet, 8¹/₄ x 10¹/₂", ca. 1948; (right and quotation) *The Real Philadelphia*, © Philadelphia Business Progress Association, cover design by Jules F. Doriot, 40-page booklet with stiff cardboard cover printed by Edward Stern & Co., 8¹/₂ x 11", 1930. 23: (left and quotation) *City of New York Map and Guide*, published by the New York Central Lines, cover illustration by Stephen J. Voorhies, foldout brochure printed by the Rand McNally Company, Chicago, 3³/₄ x 8³/₈" (folds out to 18³/₄ x 25"), 1930; (right) *Our Nation's Capitol: A Factful and Colorful Guide to Washington, D.C.*, published by Washington Novelty Co.,

48-page booklet with stiff cardboard cover and map tipped-in on inside back cover, designed and printed by H.S. Crocker Co., San Francisco, ©1955. 24: (quotation and illustration) *Batavia: A Richly Favored City in Genesee Country, New York State*, published by the Batavia Chamber of Commerce, 8-page booklet, 8 x 9", 1930. 25: (left) *A Welcome Awaits You in Historic Frederick, Md.*, published by The News-Post, foldout brochure, 7¹/₂ x 9" (folds out to 15 x 18"), ca. 1925; (quotation) *LIBERTY Sullivan Co. New York*, presumably issued by the town itself, 16-page booklet printed by The Morrill Press, Fulton, N.Y., 5¹/₂ x 7⁷/₈", Fall and Winter, 1902–03; (upper right) *Delaware*, smooth-finish advertising postcard issued by Mobilgas, c. 1950; (lower right) *Saratoga Floral Fete, Floral Parade and Carnival*, published by the Floral Association of Saratoga Springs, N.Y., 16-page booklet with stiff cardboard cover, 4 x 9", 1900. 26: *Pinehurst North Carolina*, presumably published by the town itself, 32-page booklet, 8 x 9", ca. 1925. 26–27: *The Land of the Sky: Western North Carolina*, © the Southern Railway, 32-page booklet with stiff cardboard cover, 7³/₄ x 11", 1913. 28: (left) *Kentucky: Where Hospitality Is a Tradition*, published by Division of Publicity, Frankfort, foldout brochure, 3¹/₂ x 8¹/₂" (folds out to 14 x 17"), ca. 1950; (right) *Carry Me Back to Old Virginia*, published by the Virginia Conservation Commission, Richmond, 80-page booklet, ca. 1940; (quotation) *Blue Grass Tours*, published by Henry MacNair, The Motorway Series, 64-page booklet with foldout map tipped-in on page 1, 4 x 9", © C. Frank Dunn, 1925. 29: (left) *Burlington North Carolina: The Ideal Industrial Center*, presumably published by the town itself, foldout brochure, 11¹/₄ x 9" (folds out to 18 x 22¹/₂"), ca. 1940; (upper right) *Visit Vicksburg Mississippi*, published by the Chamber of Commerce, 8-page booklet, printed by Van Norman, Inc., 8 x 9", ca. 1935; (lower right) *New Louisiana . . . The Land of Opportunity: The South's Treasure Chest of Natural Resources*, published by the Department of Commerce and Industry, Baton Rouge, foldout brochure, 4¹/₁₆ x 9¹/₄" (folds out to 16¹/₄ x 18"), ca. 1950. 30: (left and quotation) *Orlando: The City Beautiful in the Lake Section of Central Florida*, published by the Greater Orlando Chamber of Commerce, 8 x 9", 16-page foldover booklet, printed by The Rollins Press, ca. 1930; *Florida Cuba*, published by the Louisville & Nashville Railroad, 12-page foldover booklet, printed by Poole Bros. Chicago, 8 x 9", 1940. 31: (left) *Savannah Georgia*, published by the Chamber of Commerce, 16-page booklet, produced by the Review Printing Company, 8 x 9", ca. 1930; (right) *Jacksonville Florida: Where Highway, Rail, Air and Water Meet*, published by the City of Jacksonville, foldover brochure, 4 x 9" (folds out to 12 x 18"), 1928; (top quotation) *Georgia, The Empire State of the South: Today's Land of Opportunity*, published by Georgia Century of Progress Commission, 24-page booklet, 5¹/₄ x 7⁵/₈", ca. 1933; (bottom quotation) *Outwitting Winter in the Cities of the Sun*, published by the Miami Chamber of Commerce, prepared by Graydon E. Bevis, 32-page booklet, 8 x 9", © 1935 by the City of Miami. 32: (line art at left) *Yankton: Mother City of the Dakotas—Gateway to the Great Northwest*, published by the Yankton, S.D., Chamber of

Commerce, foldover brochure, 8 x 9", ca. 1930; (right) *Imperial County California: America's Winter Garden*, published by the Imperial County Board of Trade, 28-page booklet, produced by the Elite Printing Co., El Centro, Calif., 8 x 9", 1927. 33: (left) *Manatee County Florida*, published by the Manatee County Publicity Bureau, Bradenton, 10-page booklet, produced by Lassing Publishing Co., St. Petersburg, 3⁷/₈ x 9", ca. 1925; (right) *Opportunities Industrial, Asheville, N.C., "Land of the Sky,"* published by the Asheville Board of Trade, 24-page booklet produced by Hackney & Moale Co., 8 x 9", 1923; (quotation) *Yankton: Mother City of the Dakotas—Gateway to the Great Northwest*, published by the Yankton, S.D., Chamber of Commerce, foldover brochure, 8 x 9", ca. 1930. 34: (upper left) *Pride of the Catskills*, vegetable crate label for the Walton-Hamden Cauliflower Growers Co-op, Inc., Walton, N.Y., issued by the Florida Grower Press, Tampa, 10 x 11", date unknown; (lower left) Souvenir decal produced by the Duro Decal Co., Chicago, 4 x 3", date unknown; (quotation) *Rapid City in the Black Hills of South Dakota*, 8-page foldover brochure published by the Rapid City Commercial Club, printed by The Guide-Better Printers, Rapid City, 8 x 9" (folds out to 32 x 9"), 1928. 34–35: *Bradentown Florida In "The Land of Manatee,"* published by the Board of Trade, Bradentown, 24-page booklet, produced by J.P. Bell Company, Lynchburg, Va., 7³/₄ x 9", 1916. 35: (top) *Greetings from Iowa*, large setter linen postcard produced by The Dexter Press, Pearl River, N.Y., 5¹/₂ x 3¹/₂", ca. 1950; (quotation) *The State of Iowa Welcomes You*, published by the State of Iowa, Des Moines, 84-page booklet, 6 x 8³/₄" high, 1950. 36: *Come to Detroit*, published by Detroit Convention and Tourist Bureau, die-cut foldover brochure, 10¹/₂ x 4¹/₂" (folds out to 42 x 9"), ca. 1940; (quotation) *CHICAGO: The Vacation City*, issued by the Passenger Department, Illinois Central Railroad, 48-page booklet produced by the Cunoe Press, Chicago, 6⁵/₈ x 10", 1931. 36–37: *Seeing Greater Chicago by the Chicago Surface Lines*, published by the Chicago Surface Lines, 32-page booklet, produced by Printing Products Corp., with map tipped-in on inside back cover, 5 x 8¹/₂", 1929. 37: (right and quotation) *Cleveland The Vacation City*, © the Convention Board, Cleveland Chamber of Commerce, 16-page booklet, 7¹/₂ x 8³/₄", 1930. 38: (top quotation) *Visitors Find Real Hospitality at Oblong, Illinois*, published by Department of Business and Economic Development Division of Tourism, one-page foldout brochure, 10⁷/₈ x 8¹/₂", ca. 1960; (right) *Hibbing in the Heart of The Arrowhead*, presumably published by the town itself, foldover brochure, 4³/₄ x 9³/₈" (folds out to 17 and 23"), ca. 1930; (left and quotation) *Liberal, Kansas*, published by the Liberal Chamber of Commerce, foldover brochure, 3³/₄ x 8³/₈" (folds out to 10 x 14"), ca. 1950, and windshield decal produced by Duro Decal Co., Chicago, within the folded brochure, 4¹/₂ x 3", date unknown. 38–39: *Iron County Wisconsin: Wisconsin's Vacation Paradise*, published by Iron County Advertising Association, foldover brochure, 12 x 9" (folds out to 23 x 17¹/₂"), ca. 1950. 39: (right) *Wisconsin: Vacation-Land of Woods and Waters, Where Miles are Smiles*, published by the Wisconsin

Department of Agriculture and Markets, 16-page booklet, 7¹/₂ x 9", 1932; (quotation) *Tomahawk Wisconsin: In the Heart of Wisconsin's Vacationland*, published by the Tomahawk Chamber of Commerce, 16-page booklet, 8 x 9", ca. 1965. 40: (left) *Carefree Days in West Michigan: Water Wonderland*, published by the West Michigan Tourist and Resort Association, 160-page booklet, 8 x 10¹/₂", ca. 1958; (right) *West Virginia*, © West Virginia Department of Agriculture, cover illustration by Hunter, 40-page booklet, 8 x 9¹/₄", 1931; (quotation) *Go to Hell: Where They're Building a Little Heaven*, published by the Hell, Mich. Chamber of Commerce, one-page fold-over brochure, 8¹/₂ x 11", ca. 1970. 41: (left and quotation) *Missouri: An Outdoor Guide*, published by the Missouri Game and Fish Department, foldout brochure, 12 x 9" (folds out to 24 x 18") produced by the Midland Printing Co., Jefferson City, ca. 1935; (right) *Kansas Travel and Recreational Guide*, published by the Kansas Industrial Development Commission, 64-page booklet, 9¹/₄ x 6", 1958. 42: (right and quotation) *Arizona Welcomes You*, published by the State Highway Commission, cover illustration by George M. Avery, foldout brochure, 10³/₄ x 8¹/₂" (folds out to 16¹/₂ x 21¹/₄"), ca. 1935. 43: (right) *Mesa Arizona in Arizona's Valley of the Sun*, published by the Chamber of Commerce, 8-page booklet, 9 x 12", ca. 1950; (left) *Tucson Arizona*, published by Tucson Chamber of Commerce, 12-page booklet produced by Acme Printers, Tucson, 4 x 9", 1939. 44: (left) *Truth or Consequences New Mexico: "Hello There!" We've Been Waiting for You*, published by the Truth or Consequences Chamber of Commerce, foldout brochure, 8 x 9" (folds out to 16 x 18"), ca. 1950; (right) *New Mexico: "Land of Enchantment,"* published by the State Tourist Bureau, 14-page booklet, 8 x 9", ca. 1940. 45: (left and quotation) *Albuquerque*, © Albuquerque Civic Council, 28-page booklet with stiff cardboard cover, 6 x 9", 1925, fifth printing, 1929. 46: *El Paso: Sunshine Playground of the Border*, published by the El Paso Sunland Club, foldout brochure, 4 x 9" (folds out to 12 x 18"), ca. 1940; (quotation) *New Orleans: America's Most Interesting City*, published by the New Orleans Association of Commerce, foldover brochure, 4 x 9" (folds out to 20 x 9"), ca. 1930. 47: (left) *Oklahoma City: A Visitor's Guide*, published by the Oklahoma City Chamber of Commerce, foldout brochure, 7¹/₂ x 8³/₄" (folds out to 17¹/₄ x 22²/₄"), 1930; (right) Tulsa windshield decal, 3¹/₈ x 4¹/₂", date unknown; (quotation) *"Oklahoma: The 'Sooner' State,"* © Conoco Travel Bureau, Denver, 8-page booklet, 8 x 9", 1933. 48: (left, line art) See page 51 right; (right) *Hittin' The High Spots in Montana*, published by Mountains, Inc., Helena, cover art by Shorty Shope, foldover brochure, 8⁵/₁₆ x 11" (folds out to 17¹/₄ x 22"), ca. 1940. 49: (left) *Casper: the Hub of Wyoming, Gateway to the Last Frontier*, presumably published by the town itself, 8-page booklet, 7³/₄ x 8¹/₂", ca. 1935; (right) *Arizona Welcomes You*, published by the State Highway Commission, illustration by George M. Avery, foldout brochure, 10³/₄ x 8¹/₂" (folds out to 16¹/₂ x 21¹/₄"), ca. 1935. 50: (left) *Reno: Fun Center of the West*, © the Reno Chamber of Commerce, foldout brochure, 4 x 9" (folds out to 18 x 24"), 1953; (right) *Nevada: Valley of Fire*, published by the Nevada Department of Economic

Development, Carson City, foldover brochure, 4 x 9" (folds out to 9 x 12"), ca. 1955; (quotation) *South Dakota, Land of Enchantment,* published by the South Dakota State Highway Commission, Pierre, 16-page booklet, produced by S. D. Engraving Co., Sioux Falls and State Publishing Co., Pierre, 8 x 9", 1938. 51: (left and quotation) *Las Vegas Nevada: Howdy Podner! Come On Out Just for Fun,* presumably published by the town itself, 12-page color booklet, 8 x 9", ca. 1950; (right) *Days of '76 Souvenir Program, Deadwood, in the Black Hills of South Dakota: It's Wild—It's Western—It's Real!,* published by the Deadwood Chamber of Commerce, 16-page booklet with stiff cardboard cover, 6 x 9", 1937. 52: (left, line art) One-page insert to *Picture Writing,* (see page 53 right); (right) *Apache Trail,* © the Southern Pacific Lines, 4-page booklet, 12 x 9", 1929. 53: (left) *Arizona Indian Exposition and Trading Post,* published by M.W. Billingsley, foldover brochure, 4⅝ x 10½" (folds out to 13½ x 10½"), 1929; (right) *Picture Writing,* published by the Montana Highway Department, 10-page booklet, produced by Tribune Printing Co., Great Falls, cover art by Irvin (Shorty) Shope, 8½ x 11", 1938. 54: (left) Front striker matchbook cover for Soboba Mineral Hot Springs, San Jacinto, Calif., 1½ x 4½", produced by Lion Match Co., Los Angeles, date unknown; (right) *Manistique Michigan: The Land of Hiawatha and the Blazed Trail,* published by the Manistique Chamber of Commerce, foldover color brochure, 4 x 9" (folds out to 12 x 9"), ca. 1930; (quotation) *Tourist Guide of Menominee County: Gateway Headquarters . . . Upper Michigan's Hiawathaland,* published by Menominee County Tourist Council, foldout brochure, 4 x 9" (folds out to 32 x 44"), ca. 1940. 55: (left) *The Adirondacks,* © The Adirondack Resorts Association, Plattsburgh, N.Y., cover illustration by Mique Sheehan, 12-page booklet, produced by the Matthews-Northrup Works, Buffalo, Cleveland, and New York, 9⅜ x 7⅞" (cover illustration 4⅝ x 7⅞"), 1922; (left) *Yakima,* published by the Yakima, Wash. Chamber of Commerce, cover photo by Willard Hatch, foldout brochure, 4 by 9" (folds out to 16 x 21⅝"), 1949; (quotation) Advertisement by the State of Wisconsin in *The Democratic Book of 1940,* published by the Democratic National Committee, 9¾ x 13", 184 pp. 56: (left) *Denver,* © the H.H. Tammen Curio Co., Denver, die-cut 16-page booklet, 9 x 6½", 1905; (right) *Colorado Vacations,* published by the Rock Island Lines, foldout brochure produced by the Neely Printing Co., 6½ x 10½" (folds out to 25 x 14"), 1934; (quotation) *Trinidad Colorado in the heart of the Great West,* published by the Trinidad-Las Animas Chamber of Commerce, compiled by Mees And Service, 20-page booklet, produced by Chronicle-News Job Department Print, 8½ x 8", ca. 1920. 57: (left) *See Denver,* published by the Denver Convention & Visitors Bureau, cover illustration by Hayward, 16-page booklet, 8 x 9", ca. 1935. 58: (left) *Salt Lake City,* published by Salt Lake City Passenger Association, foldover brochure, produced by Schmidt Litho Co., Salt Lake City, 4 x 9" (folds out to 32 x 9"), ca. 1950; (right) *See Everything in Montana,* published by the Montana State Highway Commission, designed and written by Rad Maxey, 14-page booklet produced by Naegele Printing Co., Helena, 8½ x 11", ca. 1941. 59: (left) *From Border to Border Utah, the Friendly State, Bids You Welcome,* published by the Utah Department of Publicity and Industrial Development, foldout brochure, 8 x 9" (folds out to 16 x 18"), ca. 1945; (right top) large letter linen postcard produced by C.T. Art-Colortone, Sanborn Souvenir Co., Denver, 5½ x 3½", 1940; (right bottom) *Billings Montana: The Next Great City of the Northwest,* published by the Billings Chamber of Commerce, 16-page booklet produced by the Smith Brooks Press, Denver, 12 x 9", 1917; (quotation) *Cody Wyoming, The Last of the Best of the Roaring Old West Welcomes You to Buffalo Bill Country,* presumably published by the town itself, 16-page foldover booklet, produced by the Mills Company, Sheridan, ca. 1940. 60: (left) *Southern California All-Winter Sun Festival: 300 Events—Come Early,* published by the All-Year Club Free Visitors' Bureau, foldout brochure, 5⅞ x 3½" (folds out to 17⅞ x 3½"), 1941–42. 60–61: *Southern California All the Year,* published by the All-Year Club of Southern California, foldover brochure, 8 x 9", ca. 1915. 61: (right) *Southern California: Low Altitude Mild Weather Route,* published by the Texas & Pacific Railway and the Missouri Pacific Lines, 12-page booklet, 8 x 9", ca. 1930. (quotation) *California Welcomes You, The Official Souvenir Book of Al Malaikah Temple A.A.O.N.M.S.,* 1923 Imperial Council Meeting, Pilgrimage to Washington, D.C., June 4–June 8, 80-page booklet, 12 x 9". 62: (left) *Oakland Alameda County California,* published by the Oakland Chamber of Commerce, cover illustration by Vernon Moree, 8-page booklet, produced by Goodhue Printing Co., Oakland, 8 x 9", 1927; (right) *Los Angeles,* © the Los Angeles Chamber of Commerce, foldover brochure, 8 x 9" (folds out to 32 x 9"), 1925; (quotation) *Long Beach, Southern California, Los Angeles County,* published by Municipal Convention and Publicity Bureau, foldout brochure produced by Greens, Inc., Long Beach, 4 x 9¼" (folds out to 12 x 17½"), 1933. 62–63: *San Francisco Invites You,* published by the San Francisco Convention & Tourist League, cover illustration by Maurice Logan, 16-page booklet, 8 x 9", 1920. 63: (right) *Hollywood: This is the Place,* published by the Hollywood Chamber of Commerce, 24-page booklet, 4⅛ x 9", 1937; (top quotation) *San Francisco's Famous Night-Life Party: The Original Night-Life Party at the West's Most Famous Nightspots,* published by The Gray Line, one-page foldover brochure, 4 x 9" (folds out to 12 x 9"), ca. 1956; (quotation bottom) *You'll Enjoy San Francisco,* published by San Francisco Convention and Tourist Bureau, cover illustration by M. Logan, 16-page booklet, 8 x 9", ca. 1930. 64: *Oregon Primer,* published by the Portland Chamber of Commerce, 92-page booklet, 8 x 8½", 1911. 65: *Oregon Outdoors,* published by the Southern Pacific Railroad, 48-page booklet, 8⅛ x 9⅛", 1915; (quotation) *OREGON: The Land of Opportunity,* published by The Portland Commercial Club, 64-page booklet, 6⅛ x 9¼", 1909. 66: (left top) *Miss Spokane Invites you,* published by the Spokane Chamber of Commerce, foldover brochure, 4 x 8¾" (folds out to 16 x 8¾"), 1914; (left bottom) *Ellensburg Washington in the Kittitas: "Valley of Abundance,"* published by the Ellensburg Chamber of Commerce, foldover brochure produced by the Record Press, Ellensburg, 8 x 9" (folds out to 24 x 9"), 1940; (right) *Tacoma: The City with a Snow-Capped Mountain in Its Dooryard,* published by the Tacoma Commercial Club and Chamber of Commerce, 32-page booklet, produced by Poole Brothers, Chicago, 8¾ x 11", 1912; (quotation) *Alaska and Pacific Coast Cruises,* published by Canadian National Steamships, foldout brochure printed in Canada, 8⅜ x 9¼", (unfolds to 33 x 24"), 1940. 67: (left) *Alaska Tours 1934,* published by the American Express Travel Department, 11-page booklet, printed by Edgar C. Rowe Co., 6⅞ x 10⅛", 1934, courtesy American Express Corporate Archives; (right) *Pocket Encyclopedia of Alaska the 49th State,* published by Westinghouse, foldout brochure and map produced by General Drafting Company, Convent Station, N.J., 4 x 8½" high (folds out to 20 x 16⅝"), 1959. 68: (left) *"Garden Island Tour:" Kauai,* published by the Hawaiian Tour and Travel Service, folder, 8¼ x 10¼", ca. 1945. 69, 68 line art left, and 70 (quotation): *Hawaii Romantic . . . Beautiful,* published by Matson Line and Lassco Line, 12-page booklet, 6 x 9", 1931. 70: (left) *Hawaii in a (Coco) Nutshell,* © George T. Armitage, published by the Hawaiian Service, 48-page die-cut booklet, 6¾ x 9", 1943; (right) *The Story of Hawaii,* published by the Hawaii Tourist Bureau, 32-page booklet, 1926, DeSoto Brown Collection. 71: *Hawaii Fine Anytime,* published by the Hawaii Tourist Bureau, foldover brochure produced by Honolulu Star Bulletin, 8 x 9" (folds out to 16 x 9"), 1924; (quotation) *Hawaii,* published by the Hawaii Promotion Committee, Honolulu, 24-page booklet produced by the press of H.B. Crocker Co., San Francisco, 8 x 8⅞", 1903.

Seaside America

72–73: *Bar Harbor and Lafayette National Park Maine: A Scenic Wonderland of Ocean Lakes and Mountains,* published by the Bar Harbor Publicity Office, 16-page booklet, produced by Sherman Printing Co., Bar Harbor, 8¼ x 9¼", ca. 1930. 74: (left) *What's Fun in Falmouth,* © Falmouth Publishing Co., 40-page booklet, 6¼ x 9¼", 1939; (right and quotation) *Atlantic Coast Resorts: Eastern Canada & New England,* published by Canadian Pacific Railway, 20-page booklet with map tipped-in inside front cover, 8 x 9", 1916. 75: (left) *Nantucket,* published by The New York, New Haven and Hartford Railroad Company, The New England Steamship Company and The New Bedford, Martha's Vineyard and Nantucket Steamboat Line, written by Walter Prichard Eaton, cover illustration and drawings by John Held, Jr., 48-page booklet, produced by Rand McNally & Co., New York, 5⅜ x 8¼", ca. 1930; (right) *Old Orchard Beach: "The Center of Vacation Land,"* published by the Old Orchard Beach Chamber of Commerce, 16-page booklet and foldout map within, 4 x 9¼", ca. 1955. 76: (left) *Myrtle Beach South Carolina: "Riviera of the South,"* published by the Great Myrtle Beach Chamber of Commerce, foldover brochure designed by Advertising Service Agency, Charleston, lithographed by the Baughman Company, Richmond, Va., 8 x 9", ca. 1955; (right) *Coney Island,* presumably published by the resort itself, 56-page booklet produced by the Press of the Coney Island Times, 8¼ x 11", 1924. 77: (left top) *Ocean City New Jersey: America's Greatest Family Resort,* published by the Ocean City Publicity Department, foldout brochure, 8 x 8¾" (folds out to 31½ x 17"), ca. 1940; (left bottom) *Atlantic City,* published by the Atlantic City Vacation Bureau, foldover brochure, 8 x 9" (folds out to 20 x 9"), ca. 1950; (right top and quotation) *Cool Cape May New Jersey,* published by the Mayor and Council, City of Cape May, 16-page booklet, 8 x 9¼", ca. 1920. 78: (left) *Daytona Beach, Florida,* published by the Daytona Beach Chamber of Commerce, 12-page booklet, 8⅛ x 9", ca. 1930; (right) *Fort Lauderdale, Florida, "The Tropical Wonderland,"* published by the Fort Lauderdale Chamber of Commerce, 8-page booklet, 8 x 9", ca. 1930. 79: (left and quotation) *Palm Beach County, Florida,* published by the Board of County Commissioners, Palm Beach County, printed by The Record Company, St. Augustine, Fla., 20-page booklet, 8 x 9", ca. 1925; (right) *All Roads Lead to Key West Florida: The Paradise of America,* presumably published by the city itself, foldout brochure, 8 x 9" (folds out to 12 x 18"), 1929. 80 (line art, left) and 81: *Miami Beach,* © the Miami Beach Chamber of Commerce, 16-page booklet, 8 x 9", 1937. 80: (right) *Miami—By the Sea: "The Convention City,"* © the City of Miami, 36-page booklet, produced by the Record Company, St. Augustine, Fla., 8 x 9", 1927. 82: (left) *Miami Beach and Miami Florida,* presumably published by the city itself, 32-page booklet with a two-page foldout center spread, produced by the Parker Art Printing Assn., Coral Gables, 8 x 9", 1931; (center) *Miami Beach: Fun on a Budget,* published by the Atlantic Coast Railroad, foldout brochure, 4 x 9" (folds out to 16 x 18"), 1959. 82–83: *Miami Beach: Out-Door Sports Capital of America,* published by the Miami Beach Chamber of Commerce, 14-page booklet, 8 x 9", 1933. 83: (top right) *Miami Beach Florida Is Calling You,* presumably published by the city itself, 12-page booklet, produced by the Record Company, St. Augustine, 8 x 9", 1924; (bottom right) *Miami Beach Hotels + Motels,* published by the Seaboard Railroad, foldout brochure, 4 x 9" (folds out to 16 x 18"), 1966–67. 84: (left) *Sarasota Florida: The Air Conditioned City on the Gulf of Mexico,* published by the Sarasota County Chamber of Commerce, foldover brochure, 8 x 9" (folds out to 16 x 9"), ca. 1940; (right) *Pensacola on the Florida Gulf Coast,* published by the Pensacola Chamber of Commerce, 12-page booklet, printed by Poole Bros., Chicago, 8 x 9", ca. 1930. 85: *The Gulf Coast: The American Riviera,* published by the Louisville & Nashville Railroad, 64-page booklet, printed by Poole Brothers, Chicago, 16 x 9", 1930. 86: *Biloxi, Mississippi,* published by the Biloxi Chamber of Commerce, text and photographs by Anthony V. Ragusin, 12-page booklet, 7⅞ x 9", ca. 1935. 87: (left) *Come to Galveston,* published by Galveston National Hotels, cover illustration by Odell Prasther, foldout brochure, 3½ x 9" (folds out to 11¼ x 18"), ca. 1940; (right) *Corpus Christi: Port of Play and Profit,* published by the Corpus Christi Chamber of Commerce, 8 x 9", ca. 1945. 88: (left) Sea Lion Caves sticker, 4¾ x 6", date unknown; (right) *Seaside Oregon,* published by the Seaside Chamber of Commerce, foldover brochure, 4 x 9" (folds out to 12 x 9"), ca. 1950. 89: *Seaside Oregon: The Trails End City,* published by the Seaside Commercial Club, 8-page booklet, 7⅞ x 8¾", ca. 1920. 90: (left) *Redondo Beach Bath House,* presumably published by the town itself, foldover brochure, 4 x 9"

(folds out to 12 x 9"), ca. 1925; (right) *Long Beach IS Southern California . . . play here all year!*, © the Long Beach Chamber of Commerce, foldout brochure, 4 x 9" (folds out to 12 x 18"), 1957. 90–91: *Long Beach Bath House*, published by the Long Beach Bath House and Amusement Company, foldover brochure, 4 x 9" (folds out to 12 x 9"), ca. 1930. 91: (top) *Venice: America's All-Year 'Round Playground*, presumably published by the Venice Branch of the Los Angeles Chamber of Commerce, 4 x 9" (folds out to 12 x 9"), ca. 1925; (bottom) *There's More to live for in San Diego*, published by the San Diego California Club, foldover brochure, produced by Frye & Smith, San Diego, 3¹/₂ x 8¹/₈" (folds out to 21 x 8¹/₈"), ca. 1950. 92: (quotation and center top) *Enjoy the Trip to Seal Rocks in Catalina*, published by the Catalina Operations Company, Avalon, Calif., foldover brochure, 4 x 7" (folds out to 8 x 7"), ca. 1950; (left) *Santa Catalina*, published by the Santa Catalina Island General Passenger Department, 16-page booklet, 8 x 9" high, 1941; (center bottom) *Santa Catalina Island*, published by the Santa Catalina Island General Passenger Department, 10-page booklet, produced by Magill-Weinsheimer Co., Chicago, 8¹/₈ x 8⁷/₈", ca. 1935; (right) *Catalina Island*, published by the Santa Catalina Island General Passenger Department, foldover brochure, produced by L.A. Lithograph Co., 3⁷/₈ x 9" (folds out to 31¹/₂ x 9"), 1927. 93: *Catalina Island: California's Magic Isle*, published by the Santa Catalina Island General Passenger Department, front cover (right) folds up to show opened treasure chest (left), foldout brochure, 4 x 9" (folds out to 19¹/₂ x 13¹/₄"), 1929.

Natural Attractions

94–95: *Automobile Road Guide to Yosemite: California's All-Year Playland*, published by Yosemite Park and Curry Co., foldover brochure, produced by the Press of H.S. Crocker Co., 3³/₈ x 7" (folds out to 13¹/₂ x 7"), 1926. 96: (left) *Astonishing Yellowstone*, published by the Burlington-Northern Pacific Railroad, 48-page booklet, 7 x 10", 1940. 96–97: *Glacier National Park Hotels & Tours* published by the Great Northern Railway, 28-page booklet produced by McGill-Warner Co., Saint Paul, 8 x 9", 1915. 97: (quotation) *Yellowstone National Park*, published by the Burlington-Northern Pacific Railroad, 32-page booklet, 8 x 9", 1942; (right) *Yellowstone Opens June 20*, published by the Union Pacific Railroad, foldover brochure, 8¹/₂ x 11", 1935. 98, 99, and 101: Set of national and state park poster stamps, not perforated, each 1³/₄ x 2¹/₄", ca. 1950. 98–99: *Death Valley*, published by Death Valley Hotel Company, Ltd., cover illustration by Sam Hyde Harris, 16-page booklet, produced by Adcraft, Los Angeles, 8 x 9", 1936–37. 99: (right) *Mesa Verde National Park Colorado*, published by the Denver & Rio Grande Western Railroad, 16-page booklet with oversized cover, written by Joseph Emerson Smith, prepared by Cusack-White Co., Denver, produced by Smith-Brooks, Denver, 6¹/₂ x 9⁷/₈" (cover: 6⁷/₈ x 10¹/₄"), ca. 1910. 100: (left) Front striker matchbook cover for Crater Lake and Crater Lake Lodge, produced by the Crown Match Company, 1¹/₂ x 4¹/₂", date unknown; (right) *Crater Lake*, © the Southern Pacific Lines, 8-page booklet, 8 x 9", 1928. 101: (left and

quotation) *Grand Canyon Boulder Dam Tours Inc.*, published by Grand Canyon-Boulder Dam Tours, Inc., Los Angeles, foldout brochure, 4 x 9" (folds out to 16 x 18"), ca. 1935. 102: (left) *Line art from Medford Oregon In the Shasta Cascade Wonderland*, published by the Medford Chamber of Commerce, 8-page booklet, produced by Marshall-Smith-Leonard, 8 x 9", 1933; (right) *Muir Woods—Mt. Tamalpais Circle Motor Tour*, published by the Mt. Tamalpais Ridgecrest Boulevard Co., San Francisco, foldover brochure, 4 x 9" (folds out to 16 x 9"), ca. 1925. 103: *Beneath The Big Tree of California (I Am Waiting for You)*, sheet music cover, cover illustration by E. Pfeiffer, New York, 9¹/₄ x 12¹/₈", 1919; (right top) *Greetings from Big Trees California*, © Curt Teich & Co., Chicago, large letter linen postcard, 5¹/₂ x 3¹/₂", 1950; (right bottom) Mariposa Grove, Big Trees, Yosemite National Park, black-and-white photograph, 7 x 5" high, 1931. 104: (right and top quotation) *The Flume Reservation, Franconia Notch, Lost River: Society for Protection of New Hampshire Forests*, © C.T. Bodwell, director of The Flume Reservation and the Lost River Reservation, 12-page booklet, 5¹/₂ x 7⁵/₈" high, 1938; (bottom quotation) *Among the Adirondacks: A Souvenir of the North-Eastern Section of the Great Adirondack Wilderness*, published by The James Bayne Company, Grand Rapids, Mich., string-bound 48-page viewbook, 9 x 7", ca. 1900. 104–105: *Adirondacks, Thousand Islands, Saratoga Springs*, published by the New York Central Railroad, 48-page booklet, produced by the Rand McNally Co., New York & Chicago, 8 x 8⁷/₈", 1926. 105: (top right) *Mount Washington and Thereabouts*, published by the Mt. Washington Ry. Co., Boston and Maine Railroad, 20-page booklet with stiff cardboard cover, produced by Rand Avery Supply Co., Boston, 4 x 6¹/₈", ca. 1920; (right bottom) *The Catskill Mountains*, published by the New York Central Lines West Shore Railroad, 32-page booklet, produced by Rand McNally & Co., 8 x 9", 1917. 106: (left and quotation) *The Ozarks: "The Land of a Million Smiles,"* 16-page booklet, produced by the Union Bank Note Co., Kansas City, Mo., 8 x 9", ca. 1925; (center) Windshield sticker for Mt. Ranier National Park, 2¹/₄ x 2¹/₂", 1938; (bottom) Badlands National Monument, Wall, S.D., windshield sticker, published by the Wall Drug Store, 6 x 3¹/₂", date unknown (after 1931). 106–107: *Thru the Rockies . . . Not Around Them: Glide to Romantic Rocky Mountain Wonderlands*, published by the Denver & Rio Grande Western Railroad, 80-page booklet, 8 x 8⁷/₈", ca. 1935. 107: *Pikes Peak: Colorado Springs—Manitou, Colorado*, published by the Manitou & Pikes Peak Railway (Cog Road), 16-page booklet, 7³/₄ x 8⁵/₈", ca. 1925; (quotation) *South Dakota's Black Hills and Big Badlands*, foldout brochure published by South Dakota State highway Commission, Pierre, S. D., foldout brochure, produced by Midwest-Beach Co., Sioux Falls, 4¹/₄ x 8³/₄" (folds out to 16¹/₄ x 17¹/₂"), ca. 1950. 108: (left) *A Day at Bertrand Island, Lake Hopatcong, New Jersey*, published by the town itself, foldover brochure produced by the Record Company, St. Augustine, Fla., 3 x 6" (folds out to 12 x 6"), ca. 1925; (right) *Decatur Illinois: The Playground of Central Illinois* (Lake Decatur), presumably published by The Decatur Association of Commerce, foldover brochure,

7¹/₂ x 8¹/₂", ca. 1920. 108–109: (quotation and right) *Lake Tahoe*, published by the Lake Tahoe Association, foldover brochure, 8 x 9" (folds out to 16 x 9"), ca. 1920. 109: *Lake Chelah: Cascade Mountains*, published by the Great Northern Railway, foldover brochure, 4 x 9¹/₄" (folds out to 32 x 9¹/₄"), 1921. 110: *Russian River Recreational Region in the Redwood Empire*, presumably published by the region itself, cover illustration by Juliet Hertbron, foldover brochure, 8 x 9" (folds out to 16 x 9"), 1938; (quotation) *Immortal Niagara Official Guide Book*, published by the Niagara Falls Chamber of Commerce, 56-page booklet, © the Hollings Press, Buffalo, N.Y., 5¹/₂ x 8¹/₂", 1950. 110–111: *Come to Buffalo and See the Niagara Falls Region*, published by the Board of Publicity of the City of Buffalo, 10-page booklet, produced by the J.W. Clement Co., Buffalo, 8 x 9¹/₄", ca. 1940. 111: (quotation and left) *Hudson River*, published by the New York Central Lines, 48-page booklet, produced by Rand McNally & Co., New York and Chicago, 8 x 9", 1926; (bottom) *Ausable Chasm*, published by the Ausable Chasm Company, Keesville, N.Y., 12-page booklet, 4¹/₂ x 6", ca. 1910. 112: Photograph of inscriptions made by visitors in the Blue Grotto, Harrisonburg, Va., Wittemann Collection, Library of Congress; (quotation) Advertisement in *Travel Tips*, published by Simmons Tours, New York, N.Y., 88-page booklet, © 1929, Vol. 276, Summer Edition, 1929. 112–113: *Historic Blue Grottoes, Harrisonburg, Va., Endless Caverns, Virginia, Cyclopean Towers, Mt. Solon, Virginia, Sapphire Pool Virginia in the Shenandoah Valley*, published by Endless Caverns, Inc., 10-page booklet, 8¹/₄ x 9¹/₈", ca. 1935. 114: (left) Souvenir windshield decal for Floyd Collins' Crystal Cave produced by Goldfarb Novelty Co., Jersey City, N.J., date unknown; *Ohio Caverns*, West Liberty, Ohio, presumably published by Ohio Caverns, foldout brochure, 4¹/₄ x 9¹/₈" (folds out to 12 x 17¹/₄"), ca. 1950; (quotation) *Floyd Collins' Crystal Cave in Kentucky*, published by Floyd Collins' Crystal Cave, Horse Cave, Ky., foldover brochure, 8 x 9", ca. 1940. 115: (left) *Bull Shoals Caverns and Mountain Village 1890*, presumably published by the attraction, foldout brochure, 4¹/₈ x 8¹/₂" (folds out to 20 x 17"), ca. 1950; (right top) *Carlsbad Caverns National Park*, published by Cavern Supply Co., Carlsbad, N.Mex., one-page foldover brochure, 4 x 9" (folds out to 8 x 9"), ca. 1940; (right bottom) Postcard: Scene in Wonderland Night Club, Wonder Cave, Bella Vista, Ark., produced by Curt Teich & Co., Chicago, 5¹/₂ x 3¹/₂", ca. 1930; (quotation) *Baker Caverns Pennsylvania*, published by Baker Caverns, Williamson, Pa., one-page foldover brochure, 8 x 9", ca. 1935. 116: (upper left) Line art from *Stark Caverns: Only Cave on Hi-Way 54*, published by Stark Caverns, Eldon, Mo., foldover brochure, 4 x 9" (folds out to 12 x 9"), ca. 1955; (lower left) *Natural Bridge of Virginia: One of the Seven Wonders of the World*, published by the Natural Bridge Company, © H.D. Grant, 8-page booklet, 8 x 9", 1927; (right) *Dinosaur Hunting License* presumably published by Uintah County, Utah, 6³/₄ x 7", 1964; (quotation) Advertisement in *Travel Tips*, published by Simmons Tours, New York, N.Y., 88-page booklet, 6¹/₂ x 9¹/₂", Vol. 276, Summer Edition 1929. 117: (top) Line drawing from *See Northern Arizona* magazine, Williams, Az., Vol. Nine, No. Eight, August, 1937,

p. 1; (middle) *Meteor Crater: The Grave of Arizona's Giant Meteor*, published by the Meteor Crater Observatory, Winslow, 12-page booklet, 12³/₈ x 6", ca. 1940; (lower left) *The Beautiful Dells of Wonderful Wisconsin and Exciting Attractions*, published by the Wisconsin Dells Region Chamber of Commerce, foldout brochure produced by Johnson Printing, Eau Claire, 4 x 8¹/₂" (folds out to 24 x 17"), ca. 1960; (quotation) *Start Your Outing Where The Dells Begin*, published by The Dells of Wisconsin on the Wisconsin River, one-page foldover brochure, 4 x 9" (folds out to 9 x 12"), ca. 1935.

On Vacation

118–119: *Sun Valley: A Winter Wonderland*, presumably published by the town itself, cover illustration by Spanner, 12-page booklet, 9 x 12", 1939. 120: (left) *Winter in New England*, published by the Boston and Maine Railroad, 30-page booklet, 8¹/₈ x 9¹/₄", 1932; (right) *Stowe Vermont: Ski Capital of the East*, published by the Stowe-Mansfield Association, foldover brochure, 4 x 9" (folds out to 18 x 24"), 1957. 121: (left) *Attractive Winter Resorts*, published by the Seaboard Air Line Railway, 48-page booklet, produced by the Rand McNally Co., N.Y., 8 x 9", 1916; (center) *Mountain and Lake Resorts Along the Lackawanna Railroad*, published by the railroad, 48-page booklet, 8 x 9", 1922; (right) *Lake George*, published by the Delaware & Hudson Co., foldover brochure, produced by B. Brown Printing & Binding Co., N.Y., 3¹/₂ x 7³/₄" (folds out to 28 x 7³/₄"), 1915. 122: (left) *Spokane—The Empire City!*, published by the Spokane Chamber of Commerce, foldover brochure, 3³/₄ x 9¹/₄" (folds out to 22 x 9¹/₄"), 1928; (right) *Pinehurst North Carolina*, presumably published by the resort itself, 32-page booklet, produced by the Rand Avery Supply Co., Boston, 8¹/₄ x 9¹/₄" high, ca. 1930. 123: *Tropical Trips*, published by the Atlantic Coast Line Railroad, cover illustration by Hillborn, 32-page booklet, produced by the Record Co., St. Augustine, Fla., 8¹/₈ x 9¹/₈", 1932-33; (right) *De Land Florida*, published by the City of De Land and the De Land Commercial Club, 32-page booklet, 8 x 9", 1924. 124: *Warren County, New York State, A Vacation Paradise in the Adirondack Mountains*, published by the Warren County Publicity Department, Lake George, N.Y., foldout brochure, produced by Adirondack Resorts Press, 4 x 9¹/₄" (folds out to 24 x 18¹/₄"), ca. 1960; (right) *All-Expense Cruise Tours to Virginia*, published by the Old Dominion Line of Eastern Steamship Lines, 20-page booklet, 8 x 9", 1937. 125: (left) *Detroit Lakes, Minnesota*, published by the Businessmen's Association, 24-page booklet, 8 x 9", ca. 1930; (right) *Summer Resorts in Southern New England*, published by the New York, New Haven and Hartford Railroad, the New England Steamship Company and the New England Transportation Company, 72-page booklet, produced by the J.B. Lyon Co., Albany, 8 x 9", 1935. 126: *Fish the Superior National Forest: Adventure in the Canadian Wilderness*, published by the Ely, Minn. Commercial Club, 16-page booklet, 8 x 9", 1932; (right) *Come to the Minnesota Arrowhead*, published by the Minnesota Arrowhead Association, foldout brochure, 4¹/₈ x 9" (folds out to 24 x 36"), 1926. 127: (left) *Miami Beach*, © the Miami Beach Chamber of

Commerce, 12-page booklet with six accordion-folded strips with 6 miniature views per strip (3¼ x 15¼") tipped-in on six of the pages, 4 x 8⅜", 1937; (center) *50 Fishing Waters 'round Bangor; Bird and Big Game Shooting*, published by the Bangor, Maine, Chamber of Commerce, 8-page booklet, produced by the Furbush Printing Co., 8 x 9", ca. 1925; (right) *Cape Vincent New York: The Home of the Gamy Black Bass*, cover insignia published by the Cape Vincent Chamber of Commerce, foldout brochure, 4 x 9¼" (folds out to 12 x 18½"), ca. 1930. 132: *When I say fun I mean fun: "Meet Me at Hot Springs National Park Arkansas,"* produced by the Health and Recreation Division, Chamber of Commerce, Hot Springs National Park, 32-page foldout brochure, 8 x 9" (folds out to 32 x 18"), 1935.

Back cover: *Florida: "Land of Sunshine and Happiness,"* published by the Cuesta Ray & Co., Tampa, Fla. (cigar producers), cover illustration by J. Arnold Meyer, 10-page booklet, 3½ x 6½", 1928.

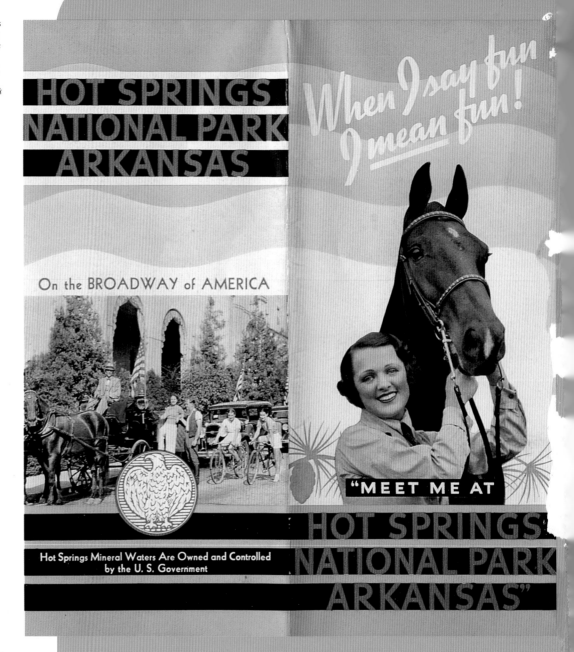